THE ILLUSTRATORS

The British Art of Illustration

1800 — 2002

THE BRITISH ART of ILLUSTRATION

THE ILLUSTRATORS

The British Art of Illustration

1800 – 2002

CHRIS BEETLES LTD

8 & 10 RYDER STREET ST JAMES'S LONDON SW1Y 6QB

Telephone – 020 7839 7551 Facsimile – 020 7839 1603

email – gallery@chrisbeetles.com website – www.chrisbeetles.com

COPYRIGHT CHRIS BEETLES LTD © 2002

8 & 10 Ryder Street
St James's
London
SW1Y 6QB

Telephone	020 7839 7551
Facsimile	020 7839 1603
Email	gallery@chrisbeetles.com
Website	www.chrisbeetles.com

ISBN 1 871136 79 2

Cataloguing in Publication Data is available from the British Library

TEXT	David Wootton and signed contributors
DESIGN	Fiona Pearce
PHOTOGRAPHY	Red Apple
COLOUR SEPARATION AND PRINTING	Hyway Printing Group

Front cover:
29 Arthur Rackham (1867-1939)
THEY QUAFFED THEIR LIQUOR IN PROFOUND SILENCE

Back cover:
40 Beatrix Potter (1866-1943)
NOW RUN ALONG, AND DON'T GET INTO MISCHIEF. I AM GOING OUT

Frontispiece:
Peter Cross (born 1951)
THE BRITISH ART OF ILLUSTRATION 2002

Below:
78 Ernest Howard Shepard (1879-1976)
WE WERE SPRAWLING ON THE LAWN

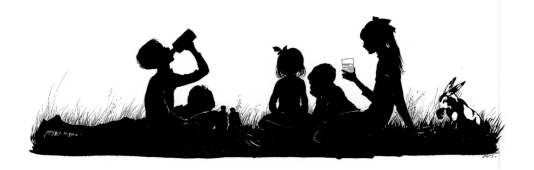

CONTENTS

	Page
Edward Lear	7-9
Charles Altamont Doyle	10-11
Richard Doyle	12
Walter Crane	13
Sir John Everett Millais	14-15
Arthur Boyd Houghton	16
From the 1860s to the 1890s: the Presence of the Past	17-18
Henry Justice Ford	18-19
Henry Ospovat	20-21
Arthur Rackham	22-29
Wagner and Rackham	26-27
Warwick Goble	30
C E B Bernard	31
William Heath Robinson	32-33
Beatrix Potter	34-35
Honor Appleton	36-37
Helen Jacobs	38
Margaret Tarrant	38-39
Mabel Lucie Attwell	40-45
John and Isobel Morton-Sale	46-49
Ernest Howard Shepard	50-56
George Belcher	57
Sir John Bernard Partridge	58
Max Beerbohm	58-59
Frank Reynolds	60
Lawson Wood	61
Charles Henry Chapman	62-64
Frank J Minnitt	65-66
R J Macdonald	67
Edward Ardizzone	68-71
Eric Fraser	72
Mervyn Peake	73
Val Biro	74-75
Walt Disney Studio	76
Sir Hugh Casson	77-81
Russell Brockbank	82-87
Vicky (Victor Weisz)	88
Giles (Carl Ronald Giles)	89
Emmwood (John Musgrave-Wood)	90-91
Fred Banbery	92-93
Norman Thelwell	94
Frank Hampson	95-101
Ronald Searle	102-108
John Burningham	109
Edward McLachlan	110-111
Jonathan Wateridge	112-113
Simon Drew	114
Mike Williams	114
Nick Butterworth	115-116
Peter Cross	117-119
Select Bibliography	120
Cumulative Index	121-123
Index	124

INTRODUCTION

To illustrate: to provide a text with pictures.

So defined, the activity encompasses many, perhaps any, visual components of collaborations between words and graphic images. As such, it may be considered a rich and versatile art, adaptable to forms that are both high and low, and traditional and modern, and able to communicate with an extreme range of child and adult audiences. The essence of this particular catalogue and of the exhibition that it accompanies, is to demonstrate this point to an unprecedented degree. Indeed, it offers a compendium of the possibilities of illustration. A newly discovered set of Edward Lear's drawings and limericks represents the primal act of creating words and images spontaneously for a private and immediate audience, with publication only as an afterthought. A parallel set of decorated cards and letters, from Hugh Casson to his friend Rosie, provides a twentieth-century counterpart. The more conventional products of illustration are as manifest, and are revealed to be widely diverse. They span the literary novel and the serious periodical through the juvenile gift books and annuals to caricatures and cartoons. Of course, the cartoon itself might convey a trenchant political message, tell an absorbing story (often as a strip), or embody the funniest anecdote. And the cartoon is almost literally a step away from animation, so that the drawings and cels that contribute to the making of a film by, say, Walt Disney are surely illustrations too. A rare still from *Snow White and the Seven Dwarves* here makes an excellent case, both as an interpretation of a text and as an image in its own right. Illustrators are first and foremost visual artists, and very distinguished painters and sculptors have also responded enthusiastically to poetry and prose. That illustration is the equal of the other visual arts is even now being recognised by our leading cultural institutions. This is exemplified by collaborations between Chris Beetles and both the Ashmolean Museum and the Dulwich Picture Gallery; the first in sponsoring *Artists of the Radio Times*, the second in supplementing a loan show of illustrations by Arthur Rackham with works for sale. Such an accessible art as illustration has a rightful place not only on the page but on the public and private wall.

David Wootton

218 Ronald Searle (born 1920)
DERE LITTLE CHAPS. PARKINS SHOWS
A GREAT DEAL OF PROMISE

EDWARD LEAR

Edward Lear (1812-1888)

'*Surely the most benificent and innocent of all books yet produced is the Book of Nonsense*' – John Ruskin

For a biography, refer to *The Illustrators*, 1996, page 63

Key works illustrated: *Illustrations of the Family of Psittacidae or Parrots* (1830-32); John E Gray (compiler), *Gleanings of the Menagerie and Aviary at Knowsley Hall* (lithographed by J W Moore and coloured by Bayfield) (1846-48)

Key work written and illustrated: *A Book of Nonsense* (1846)

His work is represented in the collections of the British Museum, the Victoria and Albert Museum and the Ashmolean Museum.

Further reading: Vivien Noakes, *The Painter Edward Lear*, Newton Abbot: David and Charles, 1991

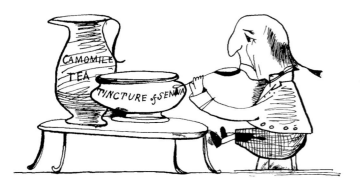

There was an Old Man of Vienna, who lived upon Tincture of Senna;
When that did not agree, he took Camomile Tea,
That nasty Old Man of Vienna

1

THERE WAS AN OLD MAN OF VIENNA,
WHO LIVED UPON A TINCTURE OF SENNA;
WHEN THAT DID NOT AGREE,
HE TOOK CAMOMILE TEA,
THAT NASTY OLD MAN OF VIENNA.
inscribed with title
pen and ink on silk
5 ½ x 9 inches

2

THERE WAS AN OLD MAN WITH A BEARD,
WHO SAID, 'IT IS JUST AS I FEARED! -
TWO OWLS AND A HEN,
FOUR LARKS AND A WREN,
HAVE ALL BUILT THEIR NESTS IN MY BEARD!'
inscribed with title
pen and ink on silk
5 ½ x 9 inches

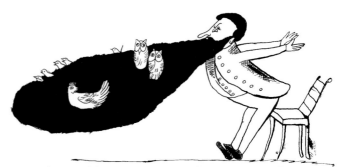

There was an Old Man with a beard, who said, "It is just as I feared!—
Two Owls and a Hen, four Larks and a Wren,
Have all built their nests in my beard!"

A BOOK OF NONSENSE

In 1846, when Edward Lear published the first edition of *A Book of Nonsense*, he can have had little idea that he had created a children's classic that never goes out of print. The twentieth of twenty-one children, he began to earn his own living at the age of fifteen as an ornithological draughtsman. It was in this role that he was invited by the Earl of Derby to visit Knowsley to make drawings of some of the creatures in his remarkable collection of exotic birds and animals.

Since boyhood, Lear had entertained his friends, young and old, with rhymes and drawings. While he was at Knowsley he was introduced to the limerick, then scarcely known as a verse form. At once he began to make new 'Old People', as he called them – Lear himself never knew the word limerick – for the children in the nursery there, and *A Book of Nonsense* was born. Lear was writing for children constrained by the demands of perfection; for them he created simple but powerfully drawn images of exuberant, sometimes disastrous, excess and spontaneity.

Original drawings for the book are rare and many of those that exist are now in libraries and museums. Sometimes, when Lear went to visit friends, he would make drawings for them and the set included here would have been made in this way. They are drawn on silk, something that Lear did only very occasionally for presentation copies. It is not known for whom they were done, but since some of the limericks appear for the first time in the new enlarged edition that he published in December 1861 they probably date from the early 1860s. It was this edition that earned him the title of 'The Father of Nonsense', and which led the general public to grasp the limerick and to develop the witty, often bawdy verse form that we now know.

Vivien Noakes

Author of *Edward Lear. The Life of a Wanderer*, London: Collins, 1968
Editor of *The Complete Nonsense and Other Verses*, London: Penguin, 2002

There was an Old Man of the West, who never could get any rest;
So they set him to spin, on his nose and his chin,
Which cured that Old Man of the West.

3

THERE WAS AN OLD MAN OF THE WEST,
WHO NEVER COULD GET ANY REST;
SO THEY SET HIM TO SPIN,
ON HIS NOSE AND HIS CHIN,
WHICH CURED THAT OLD MAN OF THE WEST.

inscribed with title
pen and ink on silk
5 ½ x 9 inches

There was an Old Man of Kilkenny, who never had more than a penny;
He spent all that money, in onions and honey,
That wayward Old Man of Kilkenny.

4

THERE WAS AN OLD MAN OF KILKENNY,
WHO NEVER HAD MORE THAN A PENNY;
HE SPENT ALL THAT MONEY,
IN ONIONS AND HONEY,
THAT WAYWARD OLD MAN OF KILKENNY.
inscribed with title
pen and ink on silk
5 ½ x 9 inches

5

THERE WAS A YOUNG LADY WHOSE NOSE,
WAS SO LONG THAT IT REACHED HER TOES:
SO SHE HIRED AN OLD LADY,
WHOSE CONDUCT WAS STEADY,
TO CARRY THAT WONDERFUL NOSE.
inscribed with title
pen and ink on silk
5 ½ x 9 inches

There was a Young Lady whose nose, was so long that it reached to her toes:
So she hired an Old Lady, whose conduct was steady,
To carry that wonderful nose.

There was an Old Man of Coblenz, the length of whose legs was immense;
He went with one prance, from Turkey to France,
That surprising Old Man of Coblenz.

6

THERE WAS AN OLD MAN OF COBLENZ,
THE LENGTH OF WHOSE LEGS WAS IMMENSE;
HE WENT WITH ONE PRANCE,
FROM TURKEY TO FRANCE,
THAT SURPRISING OLD MAN OF COBLENZ.
inscribed with title
pen and ink on silk
5 ½ x 9 inches

CHARLES DOYLE
Charles Altamont Doyle (1832-1893)

For a biography, refer to *The Illustrators*, 1997, page 17

His work is represented in the collections of the Victoria and Albert Museum and The Huntington Library (San Marino, California).

Further reading: Michael Baker, *The Doyle Diary*, London: Paddington Press, 1978 (a facsimile of Charles Doyle's sketchbook for 1889); Rodney Engen, Michael Heseltine and Lionel Lambourne, *Richard Doyle and his Family*, London: Victoria and Albert Museum, 1983; Daniel Stashower, *Teller of Tales. The Life of Arthur Conan Doyle*, London: Penguin Books, 1999; Robert R Wark, *Charles Doyle's Fairyland*, San Marino: The Huntington Library, 1980

7
GROUSE MISTAKE
YOUTH AND AGE IN NATURE
AND FAIRYLAND
inscribed with title and 'tomorrow's the 12th'
pen and ink
6 ¾ x 9 ½ inches
Taken from a sketch book of the 1880s

8
BEGGING 'HEART'S EASE'
signed with monogram, inscribed with title and dated '9th June 1888' on reverse
watercolour
7 x 10 inches

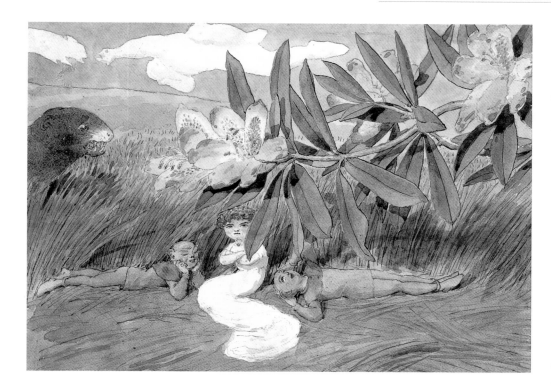

9
IN THE SHADE
watercolour
7 x 10 inches

10
THE TURTLE KISS
watercolour
7 x 10 inches

'My father, Charles Doyle, was in truth a great unrecognised genius. His mind was on strange moonlight effects, done with extraordinary skill in watercolours; dancing witches, drowning seamen, death coaches on lonely moors at night, and goblins chasing children across churchyards.' – Sir Arthur Conan Doyle

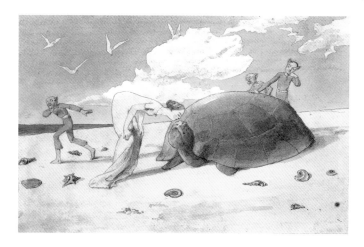

RICHARD DOYLE

Richard Doyle (1824-1883)

For a biography, refer to *The Illustrators*, 1997, pages 15-16

Key works illustrated: John Ruskin, *The King of the Golden River* (1851); William Allingham, *In Fairyland* (1870); contributed to *Punch* (1843-50)

His work is represented in the collections of the British Museum, the Victoria and Albert Museum, the Ashmolean Museum and the Fitzwilliam Museum.

Further reading: Rodney Engen, *Richard Doyle*, Stroud: Catalpa Press, 1983

'In Oberon's court, he would at once have been appointed sergeant-painter' – Austin Dobson

11

YE FAYRE SOPHIA HER ARRIVAL AT YE STATION
inscribed with title
pen and ink
6 ¼ x 9 ½ inches
Drawn for but not illustrated in *Manners and Customs of ye Englyshe. Drawn from ye quick by Richard Doyle. To which be added some extracts from Mr Pips his diary contributed by Percival Leigh*, London: Bradbury & Evans, 1849

12

PARROTS REPULSED
watercolour with pen and ink
6 x 8 ½ inches
Provenance: William Lever, 1st Viscount Leverhulme, who acquired it from Grindley & Parker, Liverpool

WALTER CRANE

Walter Crane, RI ROI RWS (1845-1915)

For a biography, refer to *The Illustrators*, 1997, pages 45-46

Key work illustrated: *The 'House That Jack Built' Alphabet* (1865) (the first of Crane's toy books, printed by Edmund Evans)

Key work written and illustrated: *Flora's Feast* (1889)

Key work written: *Of the Decorative Illustration of Books Old and New* (1896)

Further reading: Gregory Smith and Sarah Hyde, *Walter Crane: Designer and Socialist*, London: Lund Humphries/Manchester: Whitworth Art Gallery, 1989; Isobel Spencer, *Walter Crane*, London: Studio Vista, 1975

13

PANDORA

watercolour and bodycolour on tinted paper

8 x 6 inches

14

SLEEPING BEAUTY

signed with initials

watercolour and bodycolour

13 ½ x 8 inches

JOHN EVERETT MILLAIS

Sir John Everett Millais, PRA HRCA HRI (1829-1896)

John Everett Millais was born in Southampton, Hampshire, on 8 June 1829. His father was a man of independent means from an old Jersey family, while his mother came from a family of prosperous Southampton saddlers. Millais grew up in Southampton, Jersey and Dinan, in Brittany, before moving to London, in 1838, to study art. Initially, he attended Henry Sass's independent drawing academy. Then, in 1840, he entered the Royal Academy Schools, where he revealed his outstanding talent, winning several prizes, including a silver medal for drawing from the antique (1843) and a gold medal for historical painting (1847). In 1846, he began to exhibit regularly at the Royal Academy. However, his developing friendship with fellow student, William Holman Hunt, led, in 1848, to the foundation of the Pre-Raphaelite Brotherhood, which specifically rejected academic values in favour of a Romantic naturalism. A number of the works that he designated 'Pre-Raphaelite' met with controversy, but *A Huguenot*, of 1852, proved very popular with the public, in both its painted and engraved forms. His ensuing election as an associate of the Royal Academy, in the following year, led effectively to the dissolution of the Brotherhood.

In the summer of 1853, Millais visited Scotland with John and Effie Ruskin, Ruskin having been the critic who had most championed Pre-Raphaelitism. However, during the trip, Millais and Effie fell in love; as a result, Effie had her marriage to Ruskin annulled and married Millais on 3 July 1855. The newlyweds settled in Perth, staying first at Annat Lodge and then with Effie's parents at their home, Bowerswell. At this time, Millais painted distinctive symbolic images, such as *Autumn Leaves* (1855-56), and worked extensively as an illustrator.

From early in his career, Millais had demonstrated a mastery of draughtsmanship, through his illustrations for the Pre-Raphaelite magazine, *The Germ* (1850), and an unpublished series of modern moral studies (1851-55). In 1857, he confirmed his power as an illustrator through his contributions to the Moxon edition of the poems of Tennyson. Then, during the 1860s, he made significant contributions to the leading new periodicals, most notably *The Parables of Our Lord* (in *Good Words*, 1863) and his illustrations to novels by Anthony Trollope (in *The Cornhill Magazine*, 1860-69).

The latter have been considered 'arguably the best of their kind done for a novelist in the entire 19th century' (Houfe 1981: 391).

By early in the 1860s, Millais had returned to London, and reverted in his painting to the theme of ill-fated love; the resulting works proved highly popular, and earned him a greater degree of success than any other English painter. This growing status led, in 1865, to his election as a Royal Academician. Though he ceased to work regularly as an illustrator at the close of the 1860s, he did expand his repertoire as a painter, producing large-scale Scottish landscapes, inspired by holiday destinations, and establishing a highly fashionable portrait practice. The first English artist to be made a Baronet (1885), he was elected President of the Royal Academy a decade later (1896). However, he died of throat cancer soon after, on 13 August 1896, and was buried in St Paul's Cathedral. In 1898, the Royal Academy mounted a memorial exhibition.

His work is represented in the collections of the British Museum, the Victoria and Albert Museum, the Ashmolean Museum and Manchester City Art Gallery.

Further reading: Malcolm Warner, *The Drawings of John Everett Millais*, Cambridge: Fitzwilliam Museum, 1979

'There is a wonderful truth and power of expression in all he does, united with a purpose and a meaning such as are conveyed by language once vigorous and eloquent.' – Art Journal, 1866

15
SIR TRISTREM
signed with monogram
watercolour with pencil
3 ½ x 6 inches
Provenance: Harold Hartley
Illustrated: *Once a Week*, 22 March 1862, page 350, 'Sir Tristrem' by Williams Buchanan

ARTHUR BOYD HOUGHTON

Arthur Boyd Houghton, ARWS (1836-1875)

Arthur Boyd Houghton was born in Kotagiri, Madras, in 1836, the son of a draughtsman in the Hydrographic Service of the East India Company's Marine. When he was only a year old, his family returned to England, where he received a good basic education. At the age of sixteen, he enrolled at a London medical school with the intention of becoming a surgeon. However, he also attended evening classes at Leigh's School of Art and, in 1854, abandoned his medical training to enter the Royal Academy Schools. After a period of two to three years at the RA Schools, he continued his studies at the less formal Langham Sketching Club.

By the late 1850s, Houghton had begun to establish himself as a painter of contemporary genre, which he exhibited at the Royal Academy (1861-72), the British Institution and the Society of British Artists. His wife, Susan Gronow, whom he married in 1861, appeared regularly in his more domestic subjects until her death three years later, soon after the birth of their third child.

When his paintings failed to sell sufficiently well, Houghton turned to illustration, working for the Dalziel Brothers, a leading firm of wood engravers. He made a name with his illustrations to *Dalziels' Illustrated Arabian Nights Entertainments* (1863-65) and with contributions to such significant new periodicals as *Good Words*. It has been stated, with regard to the former, that he 'was the only artist on this side of the Channel to rival Doré in visual effects' (Houfe 1981: 345). Absorbing a wide range of influences, he 'evolved several distinctly different idioms' (Hogarth 1981: 43).

The founding of the *Graphic* in December 1869 gave Houghton an excellent opportunity to demonstrate his skills at visual reportage. Especially fruitful were the months he spent in the United States on behalf of the periodical, drawing many aspects of the American way of life

(1869-70); for 'the results are among his best work and perhaps the finest piece of pictorial journalism carried out by a Special Artist in the whole period' (Houfe, loc cit). Despite these successes, Houghton continued to think of himself as a historical painter, and reworked a number of his literary illustrations as oils and watercolours. Elected an Associate of the Society of Painters in Water-Colours in 1871, he contributed works in the medium to its exhibitions during the last years of his life. He died of alcoholism on 25 November 1875.

His work is represented in the collections of the British Museum, the Iveagh Bequest (Kenwood), the Royal Academy of Arts, the Tate Gallery, the Victoria and Albert Museum and the Boston Museum of Fine Arts.

Further reading: Paul Hogarth, *Arthur Boyd Houghton*, London: Gordon Fraser, 1981

16

A FANTASTIC DANCER AND GROUP OF ORIENTALS
signed with initials
pen and ink with chalk
13 x 8 inches

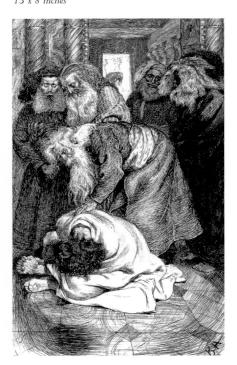

Provenance: Fine Art Society; Harold Hartley
Probably drawn for but not illustrated in *Dalziel's Bible Gallery*, London: Dalziel Brothers, 1880
Exhibited: *Loan Exhibition of Modern Illustration*, Victoria and Albert Museum, 1901, no 251; *Irish International Exhibition*, Dublin, 1907; *Grafikai Kiallitas*, Mucsarnok, Budapest, 1909; *Royal Commission International Fine-arts Exhibition*, Rome, 1911, no 781

FROM THE 1860S TO THE 1890S:
THE PRESENCE OF THE PAST

The history of illustration, and especially of the 1860s, began to be written seriously during the 1890s. Though practising illustrators had already shown awareness of the past, a more thorough sense of tradition was established late in the century with the development of a critical literature. This was headed by *English Illustration 'The Sixties': 1857-70* (1897), a volume by Gleeson White, the editor of the *Studio*, who has been called 'the most perceptive critic of the 'Nineties' (Houfe 1992: 13). White considered the 1860s not as complete and finished, but as 'part of the present', with its innovators continuing to influence the younger generation. Though some of those innovative illustrators had died (such as Arthur Boyd Houghton), others were alive (John Everett Millais), and yet others were still working (Walter Crane).

For many commentators, then as now, the 1860s was 'the golden age of Victorian illustration' (Houfe 1981: 107). Essential to its high reputation was the perfection of wood engraving as a method of reproduction, and the number of major artists that it attracted and interpreted. An increase in opportunities for those artists to illustrate was provided by an expansion in magazine publication, which was itself fuelled by a growth in the reading public. Innumerable new titles appeared on the shelves of the newsagents alongside the leading established periodicals, *Punch* and *The Illustrated London News*. These developments were noted by Gleeson White, who undoubtedly recognised parallels with his own era. Yet, while accepting that there were as many fine draughtsmen in the 1890s as in the 60s, he stated that,

> if you can find an English periodical with as many first-rate pictures as *Once a Week*, *The Cornhill Magazine*, *Good Words*, and others contained in the early sixties, you will be … well … lucky is perhaps the most perhaps the most polite word. (White 1897: 11)

Many of the periodicals new to the 1860s were given weight not only through the serialisation of novels, but by marrying the novelists to leading illustrators, as when, on several occasions, *The Cornhill* joined Millais to Trollope. However, other important illustrated texts appeared immediately in volume form. These included the phenomenally successful work of Gustave Doré and memorable examples of literature for children, from Lewis Carroll's *Alice's Adventures in Wonderland*, with illustrations by John Tenniel, to *The House that Jack Built*, the first of Crane's toy books (both 1865). The achievements were certainly many and varied, and are not easily defined.

One of the writers quoted by White considered the 'two leaders' of the illustrators of the 1860s to be Houghton and Millais , stating that 'with Millais it arrived, with Houghton it ceased' (see White 1897: 164). The writer – not identified by White – was Charles Holme, who would succeed White as editor of the *Studio* at the turn of the century. His statement appeared in *A Catalogue of forty designs by A Boyd Houghton* (1895) which accompanied an exhibition at The Sign of the Dial, the shop opened by Charles Ricketts as an outlet for the illustrated publications of his own seminal Vale Press. Two years later, Ricketts would mount an equivalent exhibition of Millais' illustrative output. Valuing both artists, Ricketts would have surely concurred with Holme's perceptive contrast of their accomplishments:

> In many of his qualities, of vitality and movement, Houghton tops Millais. What is missing from his temperament, if it be a lack and not a quality, is the power to look at things coolly; he has not, as Millais, the deep mood of stoical statement, of tragedy grown calm…But, in whatever mood he looks at things, the mastery of his aim is certain. (loc cit)

Millais and Houghton were, respectively, representatives of Pre-Raphaelitism and – what was later dubbed – the Idyllic School, and it is understandable that their approaches should differ. Nevertheless, it is interesting to note their common ground as an indicator of the period. Particularly impressive is the ability of each to range between contemporary and historical subject matter, and to instil both with essential life.

Millais' modern illustrations, as mentioned, usually relate to Trollope's novels, or look as though they ought to do so in their expression of moral crises and emotional climaxes. Houghton could exploit such a vein, but was additionally a 'special artist', that is a visual journalist producing social reportage, notably for the *Graphic*.

Their successors in the 1890s were, perhaps, more greatly inspired by their traditional themes, represented here by the Mediaeval mode of Millais and the Oriental mode of Houghton. For, by the end of the century, the historicist approach affected not only the individual illustration but the entire look of the book, from layout to typeface.

One of those who was fundamental to this development was Walter Crane, who had established his career as a wide-ranging artist-craftsman in the 1860s, and sustained it – through expansion and adaptation – into the 1890s. During the 1890s, he would make a major contribution to the Mediaevalist revival, stepping into the shoes of Edward Burne-Jones by illustrating William Morris's *The Story of the Glittering Plain* (1894) for the Kelmscott Press. But he would also publish his own critical history, *Of the Decorative Illustration of Books Old and New* (1896), and teach at Manchester School of Art and the Royal College of Art. In these ways, he provided a bridge between the Pre-Raphaelites and the younger generation of illustrators.

Crane had a direct influence on Henry Ospovat, for the young Jewish emigré studied at both Manchester and the RCA. And Ospovat seemed to acknowledge this debt in making his first published work (in the *Studio* in 1897) a tight ornamental bookplate designed specifically for Crane. Yet, in the long term, Crane's influence on him would prove less narrowly stylistic, more generally inspiring. Crane taught Ospovat to look at – and learn from – a range of earlier illustrators, and his fellow student, Oliver Onions, described Ospovat as 'poring closely over the work of the men of the "Sixties"' (Onions 1911: 111), including that of Houghton. So, as Ospovat developed, his hand relaxed, and he tempered and enhanced Romantic tropes with a solid naturalism. The same might be said of Arthur Rackham, who had cherished Houghton's work from childhood. Even Henry Justice Ford breathed a little domestic air into the intense atmosphere created by Burne-Jones. Indeed, if the 1860s had a single lesson to teach the artists of the 1890s, it was that illustration could at once display a relation to the past while communicating the ever modern spirit of vitality.

HENRY JUSTICE FORD

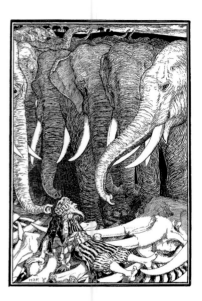

17
SINDBAD LEFT BY THE ELEPHANTS IN THEIR BURIAL PLACE
signed with initials
inscribed 'Sinbad's 7th Voyage. The elephants leave Sinbad among the bones' below mount
pen and ink
7 ¾ x 5 inches
Illustrated: Andrew Lang (editor), *The Arabian Nights Entertainments*, London: Longmans, Green and Co, 1898, page 183, 'The Seven Voyages of Sindbad: Seventh and Last Voyage'

'a prime favourite with the small people'

— Gleeson White

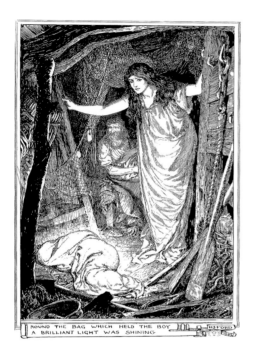

HENRY JUSTICE FORD

Henry Justice Ford (1860-1941)

Henry Justice Ford was born in London in February 1860. He was educated at Repton and Clare College, Cambridge where, in 1882, he was awarded a first in Classics. He then turned to art, studying under Alphonse Legros at the Slade School of Fine Art, and under Hubert von Herkomer at his school in Bushey, Hertfordshire. On returning to London, he established himself as an illustrator through a collaboration with the writer Andrew Lang on a highly popular series of fairy books (1889-1901). His precise illustrations were influenced in general by the Pre-Raphaelites, and in particular by the iconography of his friend, Edward Burne-Jones. This influence continued in his later, coloured illustrations. Working also as a painter of romantic and historical subjects, he was patronised by George Howard, Earl of Carlisle, and exhibited at the Royal Academy (1892-1930) and other leading venues. Solo shows were mounted at the Baillie Gallery, the Fine Art Society and the New Gallery. His last project as an illustrator seems to have been an edition of John Bunyan's *The Pilgrim's Progress* (1922). He lived latterly at Langton Maltravers, in Dorset, where he suffered a mental decline. He died on 19 November 1941.

His work is represented in the collections of the Victoria and Albert Museum.

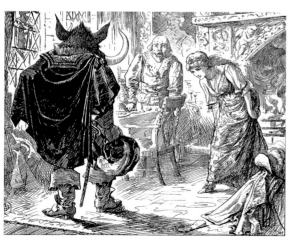

18

ROUND THE BAG WHICH HELD THE BOY A BRILLIANT LIGHT WAS SHINING
signed, inscribed with title and dated 1905
pen and ink
9 x 6 ¼ inches
Illustrated: Andrew Lang (editor), *The Red Romance Book*, London: Longmans, Green and Co, 1905, page 237, 'Havelok and Goldborough, from the Lay of Havelok the Dane'

19

BEAUTY AND THE BEAST
signed with initials
pen and ink
4 x 5 inches
Probably drawn for but not illustrated in Andrew Lang (editor), *The Blue Fairy Book*, London: Longmans, Green and Co, 1889

HENRY OSPOVAT

Henry Ospovat (1877-1909)

Henry Ospovat was born in Dvinsk (also known as Daugavpila), then on the western edge of the Russian Empire, and now in Latvia. His family was part of the large Jewish minority resident in the city. It is possible that the Ospovats left Dvinsk for England less because of persecution than in the hope of finding greater financial security. It seems that Henry was already advanced in childhood when that migration took place.

Ospovat spent the remainder of his youth within the large Jewish community of Manchester, attending the Jews' School in Derby Street and, almost certainly, a private Hebrew school. His talent as an artist was recognised by his teachers who, around the year 1893, helped to send him to the Municipal School of Art and secure his apprenticeship to a lithographer. At the school, he was encouraged by Walter Crane, the visiting Master of Design.

In 1897, Ospovat settled in London and, as the result of a scholarship, entered the Royal College of Art. Specialising in lithography, he studied under T R Way. While he was there, Crane became the college's Principal, and so continued to influence his progress. He also met George Frederick Watts and the novelist Arnold Bennett. Other inspirations included Rossetti, Sandys and Boyd Houghton, whose work he carefully studied and absorbed, as exemplified by his early designs for bookplates (including one for Crane).

In 1899, when he left the RCA, Ospovat produced an edition of *Shakespeare's Sonnets*, the illustrations for which reveal an awareness of Laurence Housman and Charles Ricketts as well as of the artists of the 1860s. This was followed by the equally exquisite and atmospheric *Poems of Matthew Arnold* (1900) and *Shakspeare Songs* (1901).

As he developed as an illustrator, Ospovat planned to publish his work in a large, portfolio format, and hoped to initiate this plan with a commission by J M Dent for an edition of Browning's *Men and Women*. However, the published volume (1903) was much more conventional in appearance, and omitted some of the more adventurous versions of the drawings. His disappointment with this project may also have affected his illustrations to Constance E Maud's *Heroines of Poetry* (1903), for few, if any, show him at his best.

Around this time he undertook 'a series of direct and hatchet-like illustrations to a series of cheap novels' (Onions 1911: 23), probably from financial necessity. Nevertheless, he remained ambitious, and planned portfolios for *Stars of the Music-hall Stage* and Chaucer's *Canterbury Tales*. These unpublished projects demonstrate his increasingly broad handling and his great skill for both character and caricature. The caricatures that were published (particularly in *Sporting Sketches* in 1907) would influence such major cartoonists as H M Bateman. Some caricatures were exhibited at the Baillie Gallery in 1908, while other works appeared in the same year at the New English Art Club and the International Society. A great talent was lost when Ospovat died in London of stomach cancer on 2 January 1909, at the age of thirty-one. A substantial memorial exhibition was held at the Baillie Gallery during the following month.

His work is represented in the collections of the Tate Gallery, the Victoria and Albert Museum and the Whitworth Art Gallery (Manchester).

Further reading: Oliver Onions, *The Work of Henry Ospovat*, London: The Saint Catherine Press, 1911

'Ospovat was among the few who can illustrate a serious author without insulting him' - Arnold Bennett

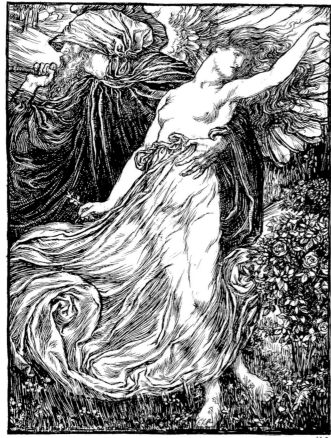

20

SONNET V

'FOR NEVER RESTING TIME LEADS SUMMER ON'

signed with initials

inscribed with title on reverse

pen and ink

7 ½ x 5 ½ inches

Illustrated: *Shakespeare's Sonnets*, London: John Lane, 1899 [unpaginated]

21

POEMS OF

MICHAEL DRAYTON

signed

pen and ink

10 x 7 inches

Illustrated: *Poems of Michael Drayton*, London: George Newnes, 1905, title page

ARTHUR RACKHAM

Arthur Rackham, VPRWS (1867-1939)

For a biography, refer to *The Illustrators*, 1999, pages 97-98;
for essays on various aspects of the artist's achievement, refer to
The Illustrators, 1997, pages 124-125; *The Illustrators*, 1999, pages
98-99; and *The Illustrators*, 2000, pages 14-15

Key works illustrated: S J Adair-Fitzgerald, *The Zankiwank and the Bletherwitch* (1896);
R H Barham, *The Ingoldsby Legends* (1898); Mrs Edgar Lewis (translator), *Fairy Tales of
the Brothers Grimm* (1900); Washington Irving, *Rip Van Winkle* (1905); J M Barrie, *Peter
Pan in Kensington Gardens* (1906); William Shakespeare, *A Midsummer Night's Dream*
(1908); Richard Wagner, *The Rhinegold and The Valkyrie* (1910); Richard Wagner,
Siegfried and The Twilight of the Gods (1911); Charles S Evans, *Cinderella* (1919); Edgar
Allen Poe, *Tales of Mystery and Imagination* (1935)

His work is represented in numerous
public collections, including the Victoria
and Albert Museum, the Butler Library
(Columbia University), New York Public
Library and the University of Texas.

Further reading: James Hamilton, *Arthur
Rackham: A Life with Illustration*, London:
Pavilion Books, 1990

23

THE INGOLDSBY LEGENDS:
WITCH IN FLIGHT
pen and ink with bodycolour
10 ½ x 9 ¾ inches
Illustrated: [Rev R H Barham] *The
Ingoldsby Legends, or Mirth & Marvels, by
Thomas Ingoldsby Esquire*, London:
J M Dent & Co, 1898, spine
(blocked in gold)

22

WINDING WITCH'S WOOL
signed and dated 1920
pen and ink with watercolour
9 ½ x 11 inches

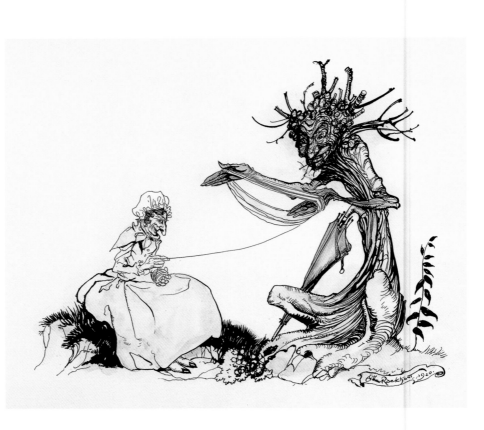

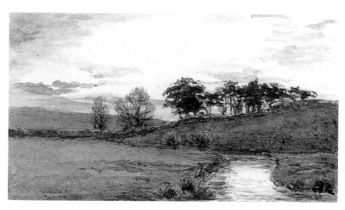

24

MYSTERIOUS PEAK

signed with initials

watercolour with bodycolour

2 x 3 ¼ inches

25

EVENING CALM

signed with initials

watercolour with bodycolour

2 x 3 ¼ inches

26

MOONLIT WATER

signed with initials

watercolour with bodycolour

2 x 3 ¼ inches

27

THE STREAM AT EVENING

signed with initials

watercolour with bodycolour

2 x 3 ¼ inches

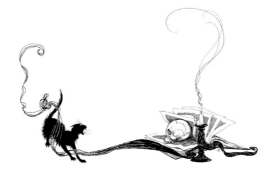

28

THE WITCH'S CAT

signed with initials

inscribed with title and story title below mount

pen and ink

9 ½ x 12 ½ inches

Illustrated: [Rev R H Barham] *The Ingoldsby Legends, or Mirth & Marvels, by Thomas Ingoldsby Esquire*, London: J M Dent & Co, 1898, endpapers

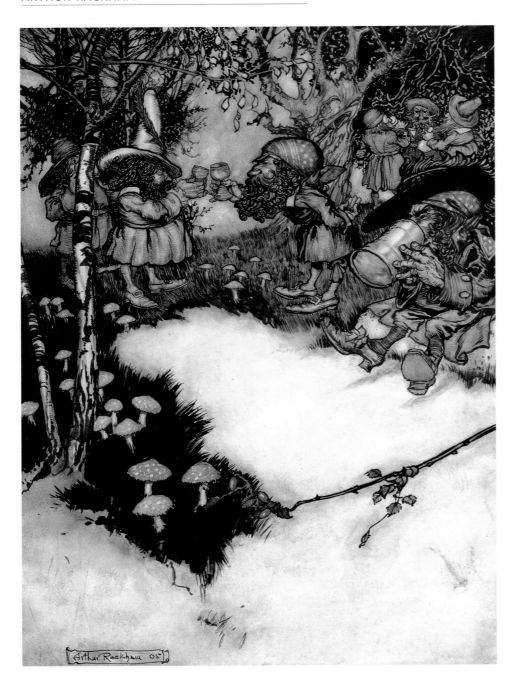

29

THEY QUAFFED THEIR LIQUOR
IN PROFOUND SILENCE
signed and dated '05
pen ink and watercolour
9 ¾ x 7 inches
Illustrated: Washington Irving,
Rip van Winkle, London:
Heinemann, 1905 [unpaginated]

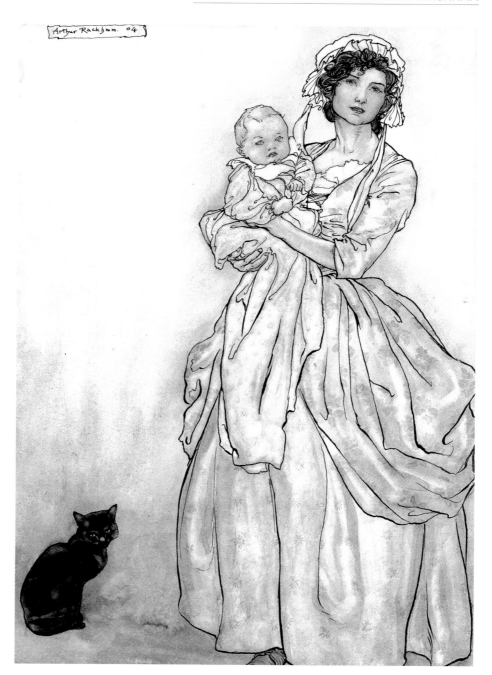

Arthur Rackham. 04

30

RIP'S DAUGHTER AND
GRANDCHILD
signed and dated '04
watercolour with pen and ink
10 x 7 inches
Illustrated: Washington Irving, *Rip
van Winkle*, London: Heinemann,
1905 [unpaginated]

WAGNER AND RACKHAM

Richard Wagner (1813-83) had an influence on the cultural life of turn-of-the-century Europe that can hardly be overestimated. The composer himself embodied the heroic artist, while his operas epitomised so revolutionary a synthesis of the arts as to be relevant to many practitioners of literary and visual disciplines as well as to musicians.

Inspired in part by the drama of Ancient Greece, Wagner developed the concept of the Gesamtkunstwerk, the total work of art, in which poetry, painting and movement would find an equal place alongside vocal and orchestral music. If the works that resulted inevitably favoured the latter elements, they still provided powerful vehicles by which to convey an intoxicating interpretation of northern mythology. To those who advocated Symbolism rather than Naturalism in the arts, these grand statements of human aspirations and universal truths had a significance that was almost religious. As a result, the festival theatre that Wagner constructed at Bayreuth was often treated as solemnly as a temple.

This religious quality is best exemplified by *Parsifal* (1865-82), 'the supreme statement of Christian mysticism and renunciation' (Wilton and Upstone 1997: 29), which was written to be performed at Bayreuth. However, it is the ambitious tetralogy *Der Ring des Niebelungen* (1847-74) which attempts the most original and thorough rehearsal of a mythos. Centring on the construction and possession of a ring that bestows both power and misfortune, its narrative suggests both a complete society and an entire history. Epic in scale and complex in content, it has given rise to many and diverse readings.

In Britain, Wagner's chief apologist was George Bernard Shaw who, in his role as a music critic, wrote *The Perfect Wagnerite* (1898), a socialist commentary on the *Ring* cycle. For equally distinctive responses in the visual arts of Britain, it is necessary to turn to such leading illustrators as Aubrey Beardsley and, particularly, Arthur Rackham. That Beardsley's sinuous line and feverish imagination made him an ideal interpreter of the intensity of Wagner's creation may be exemplified by one of his earliest mature drawings, that for Act II of *Siegfried* (the third of the *Ring* operas), published in the first issue of the *Studio* in April 1893. His numerous Wagner-inspired images have led one recent commentator, Victor Chan, to state that he was 'the English artist who made the most of Wagner's dramas' (see Wilton and Upstone 1997: 189). However, this is to ignore Rackham's more thorough achievement: a complete set of illustrations to the *Ring*, published in 1910 and 1911, grounded in a first-hand knowledge of its Rhineland setting.

Rackham's response to Wagner was one manifestation of a deep love of Germany and German culture, that was only partly filtered through the influence of Beardsley. As James Hamilton has written, 'Germany was [his] favourite holiday destination, and the [continental] country which … had the single most important influence on his art' (Hamilton 1990: 42). Before Rackham married in 1903, he undertook several walking and sketching tours through the country with a group of friends, and on at least two occasions attended the Bayreuth Festival. In 1897, he definitely saw the *Ring*, while two years later he may also have seen *Die Meistersinger von Nürnberg* (1845-67) and *Parsifal*.

It is interesting to note that Rackham considered Max Brückner's designs for the *Ring* at Bayreuth to be 'pedantic and over-detailed', for his own approach to the work would be vividly naturalistic. As such it was in keeping with Wagner's original directions, and quite different from Beardsley's stylisation. The degree to which the visual element of Wagner's conception was maintained would remain a moot point for designers through the twentieth century, with Rackham acting as a point of reference. Wagner's son, Siegfried, 'spoke in great terms' about Rackham's illustrations to the *Ring*, and hoped to meet the artist on visiting London in 1927. Even such recent designers as William Dudley (Bayreuth 1983) and Robert Israel (Seattle 1984) have turned to Rackham for inspiration in preparing for productions of the cycle.

Rackham's experience of the Rhenish topography began to reveal itself clearly in illustrations to *Fairy Tales of the Brothers Grimm* (1900) and La Motte Fouqué's *Undine* (1909). The commission by Heinemann, in 1910, for a two-volume edition of the *Ring*, in a translation by Margaret Armour, gave him the opportunity to demonstrate fully and seriously his sympathy for the Germanic character. Here was a substantial elevated text, grounded in a particular place and a traditional literature, which appealed to a mature audience.

Rackham stated in a letter to a young admirer that 'Wagner's great Music-stories…are not very well suited for those lucky people who haven't yet finished the delightful adventure of growing up' (see Hamilton 1990: 99). Yet the enthusiastic response of such a susceptible and imaginative child as the young C S Lewis demonstrated that Rackham's edition could touch people of all ages.

On the whole, *The Rheingold and the Valkyrie* (1910) and *Siegfried and the Twilight of the Gods* (1911) proved to be critical rather than popular successes when they were published and when their artwork was shown at the Leicester Galleries. The subsequent exhibition of the artwork in Paris in 1912 prompted the award of a gold medal and an associate membership by the Société Nationale des Beaux Arts. These honours confirmed that Rackham's achievement was integral to the European cultural tradition and, particularly, an appreciation of Wagner.

By the time that adoration of Wagner began to wane, with the outbreak of the First World War in 1914, Rackham had been prompted by Heinemann, his publisher, to turn away from Germanic subjects. As a result, his name tends to be identified with such quintessential classics of the English nursery as J M Barrie's *Peter Pan in Kensington Gardens* (1912) and *Mother Goose. The Old Nursery Rhymes* (1913). The illustrations to the *Ring* should be remembered as the highpoint of another, equally important, aspect of his art.

BRÜNNHILDE

To the general public, the character of Brünnhilde is synonymous with Wagner's *Der Ring des Niebelungen*, and even with grand opera as a genre. Traditionally dressed in breastplate and horned helmet, her appearance is unforgettable, especially as interpreted by such an imposing soprano as Rita Hunter. Brünnhilde is also associated with the best known piece of music in the cycle, the Ride of the Valkyries, for she is one of the Valkyries, the daughters of Wotan, the chief of the gods, who gather fallen heroes from the field of battle.

Brünnhilde is introduced in *Die Walküre*, the second opera in the cycle, when Wotan orders her to protect Siegmund, his son by a mortal woman. For Siegmund is to fight with Hunding, the husband of Sieglinde, Siegmund's sister and incestuous lover. When Fricka, Wotan's wife and the goddess of marriage, demands that Siegmund die, Brünnhilde remains true to the original order. In the interpretation by Rackham included here, she appears both heroic and feminine, as she and her steed, Grane, keep watch over the lovers (*Die Walküre*, Act II). Though Siegmund is killed, Brünnhilde escapes with the pregnant Sieglinde, and leaves her in the care of the Valkyries. Wotan punishes Brünnhilde by sending her to sleep on a mountain top, and vows that she shall become the mortal wife of the first man to wake her. However, he agrees to her qualification that she be surrounded by fire, so that only a hero dare accomplish the task. That hero will be Siegfried, the son of Sieglinde and Siegmund (*Siegfried*, Act III). The relationship of Brünnhilde and Siegfried is at once sealed and undermined when he gives her the fatal ring (*Die Götterdämmerung*, Act I).

For other illustrations to Wagner's *Der Ring des Niebelungen*, by Eric Fraser and Val Biro, please refer to pages 72 and 75

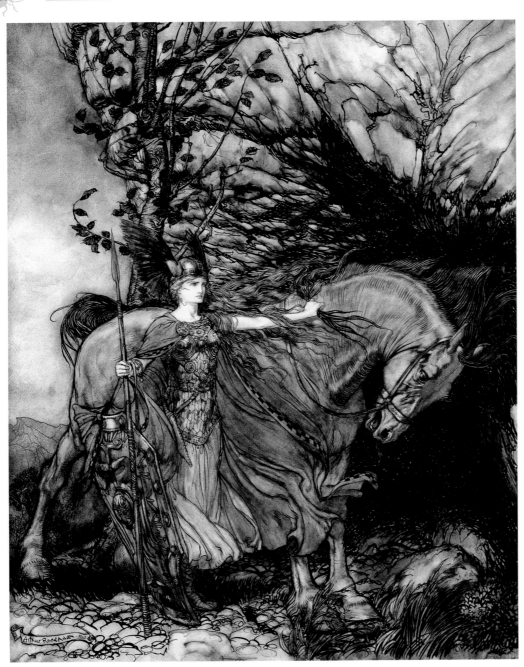

31

BRUNNHILDE

signed and dated 1910

signed and inscribed with title, artist's

address and 'no 28 Brunnhilde attends

Siegmund' on a label on original

backboard

pen ink and watercolour

20 x 14 ¾ inches

Provenance: the Venerable

Archdeacon of Warwick

Illustrated: Margaret Armour

(translator), *The Rhinegold & The*

Valkyrie by Richard Wagner, London:

William Heinemann, 1910, facing

page 102, 'The Valkyrie'

Exhibited: Leicester Galleries,

November 1910, no 33 (bought by

the Ven Archdeacon of Warwick);

Paris Salon, 1912, no 28

9 July 1911

The Ven Archdeacon of Warwick

My Dear Sir

I have beeen approached to exhibit the complete set of my illustrations to Wagner's 'Ring' at the Paris Salon of 1912 if arrangements can be made to borrow the drawings.

I am most reluctant to trouble the owners of my drawings by asking them to lend them, as I know how inconvenient it must often be, but this is, I need hardly say, a very unusual occasion. The compliment of inviting to the salon 60 or 70 drawings by a living artist must very rarely have been paid before, if ever. And it is such an unusual honour that I naturally am very anxious that the arrangements should be able to be made.

The drawings would not be wanted until early next spring but I am asked to ascertain now from the owners if they will lend their drawings so that arrangements can be made for the necessary reservation of space.

I shall be greatly indebted to you if you will be so kind as to promise to lend your drawing — 'Brunnhilde with her horses at the cave' when the time comes.

I hope you will be able to do so. Every care would be taken of it, & insurance & all other expenses would of course be paid.
Yours faithfully,

Arthur Rackham

WARWICK GOBLE
Warwick Goble (1862-1943)

For a biography, refer to *The Illustrators*, 1997, page 18

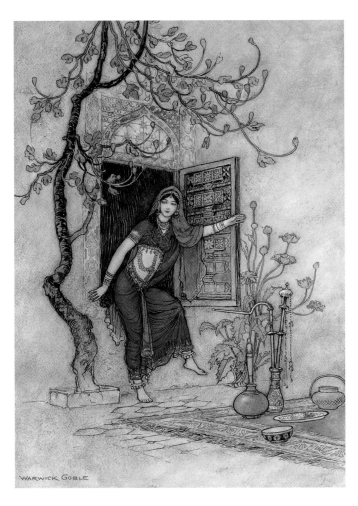

32

THE GIRL OF THE WALL-ALMIRAH
signed
watercolour with pen and ink
13 ¼ x 9 ¼ inches
Illustrated: The Reverend Lal
Behari Day, *Folk-Tales of Bengal*,
London: Macmillan and Co, 1912,
facing page 90, 'The Story of
Swet-Basanta'

33

THE MATSUYAMA MIRROR
signed
watercolour with pen and ink
9 ¾ x 13 ½ inches
Illustrated: Grace James, *Green
Willow and other Japanese Fairy Tales*,
London: Macmillan and Co, 1910,
facing page 228, 'The Matsuyama
Mirror'

C E B BERNARD

C E B Bernard (active 1914-1929)

During the 1920s, C E B Bernard contributed illustrations to *Tiger Tim's Annual* (1926), and a number of children's books published by Blackie & Son including *The Jumble Book* (1926) and *The Pixie Alphabet Book* (1928).

34

STORM BREWING

signed

watercolour with bodycolour

12 ½ x 8 ¾ inches

35

PEACOCKS AT MIDNIGHT

signed

pen ink and watercolour

11 ½ x 8 ½ inches

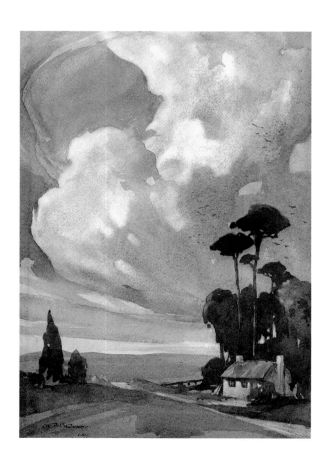

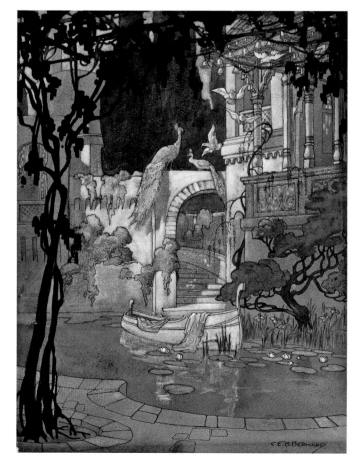

WILLIAM HEATH ROBINSON

William Heath Robinson (1872-1944)

For a biography, refer to *The Illustrators*, 1999, pages 72-73; for essays on various aspects of his achievement, refer to *The Illustrators*, 1996, pages 112-113; *The Illustrators*, 1997, pages 124-125; *The Illustrators*, 1999, pages 73-74; and *The Illustrators*, 2000, pages 17-18

Key works written and illustrated: *The Adventures of Uncle Lubin* (1902); *Bill the Minder* (1912)

Key works illustrated: *The Poems of Edgar Allan Poe* (1900); *The Works of Mr Francis Rabelais* (1904); *Hans Andersen's Fairy Tales* (1913); Shakespeare, *A Midsummer Night's Dream* (1914); Walter de la Mare, *Peacock Pie* (1918); contributed to the *Bystander* (from 1905) and the *Sketch* (from 1906)

His work is represented in the collections of the British Museum, the Cartoon Art Trust and the Victoria and Albert Museum.

Further reading: Geoffrey Beare, *The Illustrations of W Heath Robinson*, London: Werner Shaw, 1983; Geoffrey Beare, *The Brothers Robinson*, London: Chris Beetles, 1992; Geoffrey Beare, *Heath Robinson Advertising*, London: Bellew, 1992; James Hamilton, *William Heath Robinson*, London: Pavilion Books, 1992; John Lewis, *Heath Robinson. Artist and Comic Genius*, London: Constable, 1973

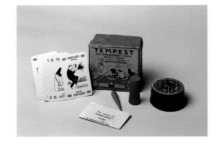

36 (below left)
THE MIDNIGHT FEAST
signed; pen and ink; 8 x 10 ¼ inches
Probably drawn for but not illustrated in *Heath Robinson's Book of Goblins*, London: Hutchinson & Co, 1934, facing page 176, 'The Three Millers'

37
TEMPEST.
AN UPROARIOUSLY
FUNNY GAME
Cards designed by W Heath Robinson and produced by Thomas De La Rue & Co Ltd.
A wild exhilarating card game in which 4-8 players compete to become the Prevailing Wind. Hot air and strong breath are definite advantages in keeping control of the Weather Vane.

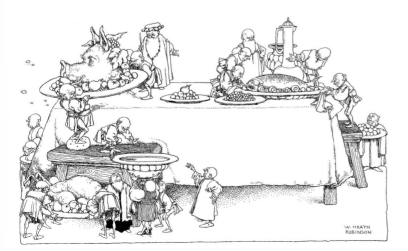

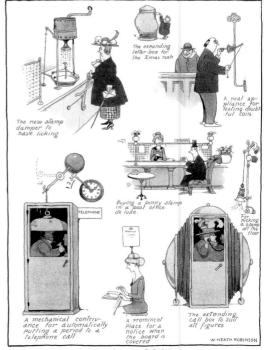

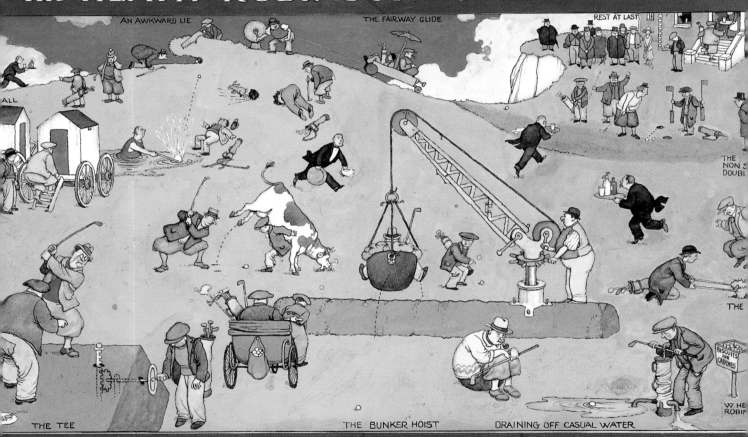

38 (left)
POSTAL REFORM. A FEW SUGGESTIONS
signed and inscribed with title and 'Post Annual'
pen ink and monochrome watercolour; 16 x 12 inches
Illustrated: The Post Annual, 1921, page 11

39
THE HEATH ROBINSON GOLF COURSE PACKED WITH PEEK FREAN'S BISCUITS
signed
watercolour and bodycolour
12 ½ x 19 inches

BEATRIX POTTER

Helen Beatrix Potter (1866-1943)

Beatrix Potter was born in South Kensington, London, on 28 July 1866, the daughter of a barrister who chose to live as a dilletante, with painting and photography numbered among his interests. Beatrix herself led a very sheltered life for many years, remaining with her parents until she was nearly forty. Educated at home, she was entirely self-taught as an artist. She sketched fungi, fossils and fabrics in the South Kensington Museums, and animals, both furtively at home, and during family summer holidays in the Lake District and Scotland. Then developing an interest in illustration, she absorbed the influence of Thomas Bewick, Randolph Caldecott, Walter Crane and John Tenniel, as she published some greetings' cards and a first book, *The Happy Pair* (both 1890). Three years later, she invented the character of Peter Rabbit in a series of picture-letters for Noël Moore, the son of her former companion, Annie Carter. These formed the basis of *The Tale of Peter Rabbit*, which was privately printed in 1900, and finally accepted by Frederick Warne & Co two years later. This was followed by several more of her classic tales.

After a fierce battle with her parents, in 1905, Potter became engaged to Norman Warne, her editor, though two years later he died. Soon after, she bought Hill Top Farm at Sawrey, near Windermere, gaining a measure of independence and becoming a capable farmer. During the following eight years she produced much of her best work, and both her home and the adjacent Castle Farm, which she bought in 1909, were used as the settings for at least six of her books. Originally published in a variety of forms, each volume had its appearance tailored to a particular text, and the integration of word and image was carefully considered. Though Potter made use of a basic anthopomorphism, she tended to eschew further fantasy, and the great success of her illustration often lies in the sense it gives of particular place.

Following her marriage to William Heelis, an Appleby solicitor, in 1913, Potter drew little and spent much of her time farming. She died at Hill Top Farm on 22 December 1943. Her properties were bequeathed to the National Trust.

Her work is represented in the collections of the British Museum, the Tate Gallery and the Victoria and Albert Museum.

Further reading: Margaret Lane, *The Tale of Beatrix Potter*, London: Warne, 1946; Anne Carroll Moore, *The Art of Beatrix Potter*, London: Warne, 1955; Judy Taylor, *Beatrix Potter, artist, storyteller and countrywoman*, London: Warne, 1986

40

NOW RUN ALONG, AND DON'T GET INTO MISCHIEF. I AM GOING OUT
signed and dated 1927
pen, ink and watercolour
4 ½ x 4 inches
Similar to Beatrix Potter, *The Tale of Peter Rabbit*, London: Frederick Warne & Co, 1902, page 17
Exhibited: The Casson Galleries, Boston, 1927

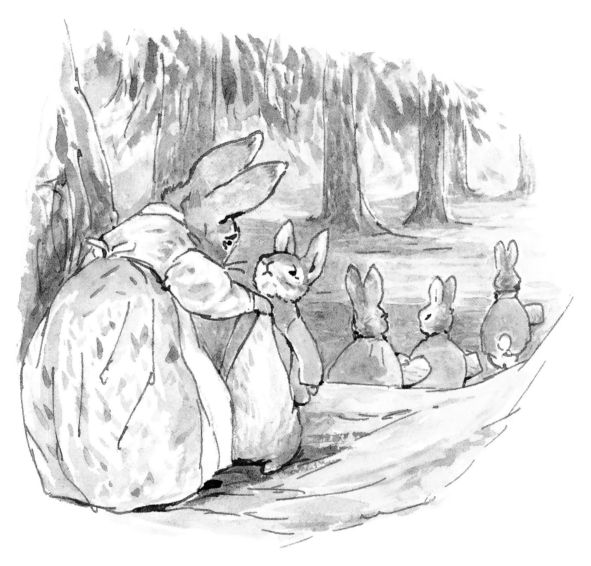

Beatrix Potter
1927

HONOR APPLETON

Honor Charlotte Appleton (1879-1951)

For a biography, refer to *The Illustrators*, 1997, Page 22

Key work illustrated: H C Cradock, *Josephine and her Dolls* (1916) (the series continuing until 1940)

Further reading: *Honor C Appleton*, London: Chris Beetles Ltd, 1990

41

THEY BOUNCED ABOUT ON THE SPRINGS
signed and inscribed with title below mount
watercolour with bodycolour
9 ½ x 7 inches
Illustrated: Mrs H C Cradock,
Josephine Keeps House, London:
Blackie & Son, 1931, frontispiece

42

JOSEPHINE'S PANTOMIME
signed with initials
pen and ink
9 ¼ x 6 ¼ inches
Illustrated: Mrs H C Cradock,
Josephine's Pantomime, London:
Blackie & Son, 1939, title page

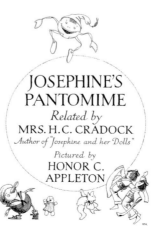

JOSEPHINE'S
PANTOMIME
Related by
MRS. H.C. CRADOCK
Author of 'Josephine and her Dolls'
Pictured by
HONOR C.
APPLETON

BLACKIE·AND·SON·LIMITED
· LONDON·AND·GLASGOW ·

43

A FAT BOUNCING BOY...CAME TUMBLING HEAD OVER HEELS ON TO THE STAGE
signed and inscribed with title below mount
watercolour with bodycolour
9 ½ x 7 inches
Illustrated: Mrs H C Cradock,
Josephine's Pantomime, London:
Blackie & Son, 1939,
frontispiece

44

THEY WERE LOOKING SO HAPPY

signed and inscribed with title below mount

watercolour with bodycolour

9 ½ x 7 ¼ inches

Illustrated: Mrs H C Cradock, *Josephine Keeps School*, London: Blackie & Son, 1920, facing page 44

Exhibited: Cecil Higgins Art Gallery, *Wonderland: an exhibition of children's book illustrations*, 17 July - 28 October 2001

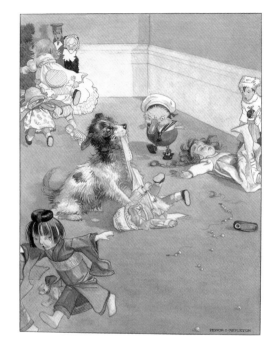

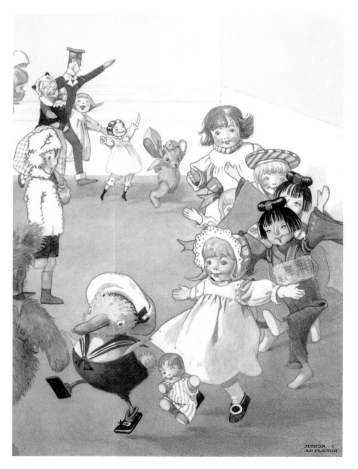

45

JOHN AND I COULDN'T THINK HOW IT HAD HAPPENED

signed, inscribed 'He's been doing dreadful things said Cook' and with publication details below mount

watercolour with bodycolour

9 ¾ x 7 inches

Illustrated: Mrs H C Cradock, *Josephine's Birthday*, London: Blackie & Son, 1920, frontispiece

46

JOSEPHINE'S BIRTHDAY

pen and ink

10 ½ x 8 ½ inches

Illustrated: Mrs H C Cradock, *Josephine's Birthday*, London: Blackie & Son, 1920, title page

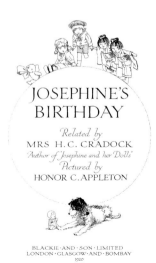

HELEN JACOBS

Helen Mary Jacobs, BWS (1888-1970)

For a biography, refer to *The Illustrators*, 1997, page 24

47

THEY BOUND ME WITH THEIR SILKEN CHAINS AND CARRIED ME AWAY
signed and dated 1919; watercolour with pen and ink; 14 ¾ x 9 ¾ inches
Illustrated: *Little Folks*, 1920, page 43, 'A Lost Fairyland' by Christine
Chaundler

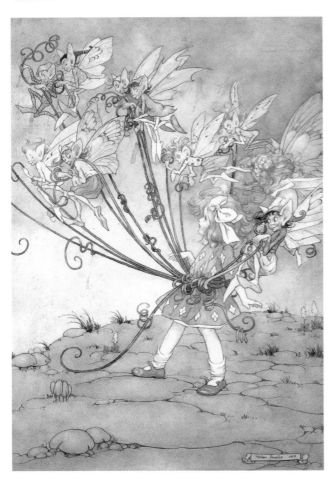

MARGARET TARRANT

Margaret Winifred Tarrant (1888-1959)

For a biography, refer to *The Illustrators*, 1997, page 24

48 (left)
DAY AND NIGHT
WHEN THE GOLDEN DAY IS DONE,
THROUGH THE CLOSING PORTAL,
CHILD AND GARDEN, FLOWER AND SUN,
VANISH ALL THINGS MORTAL.
signed
inscribed with title below mount
watercolour and bodycolour
8 ½ x 6 ¼ inches
Drawn for but not illustrated in Harry Golding (editor), *Verses for Children*,
London: Ward Lock & Co, 1918, page 239, 'Night and Day' by Robert
Louis Stevenson

49
CAPTIVE PAN
signed
watercolour and gold with bodycolour
4 x 9 ½ inches

MABEL LUCIE ATTWELL

Mabel Lucie Attwell, SWA (1879-1964)

For a biography, refer to *The Illustrators*, 1997, page 22

Key works illustrated: *The Mabel Lucie Attwell Annuals* appeared between 1922-74

Further reading: Chris Beetles, *Mabel Lucie Attwell*, London: Pavilion Books, 1985; John Henty, *The Collectable World of Mabel Lucie Attwell*, Shepton Beauchamp: Richard Dennis, 1999

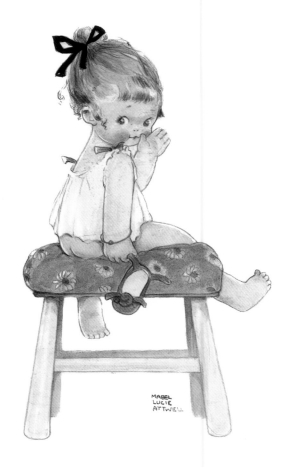

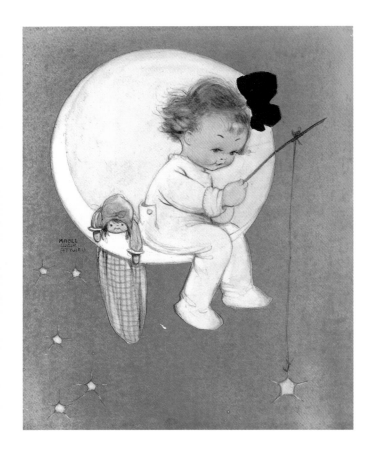

50

I'M FISHING FOR A STAR
signed
watercolour
12 ½ x 10 inches

51

SECRET
signed
watercolour and bodycolour
11 ½ x 9 inches
Provenance: the Estate of Mabel
Lucie Attwell

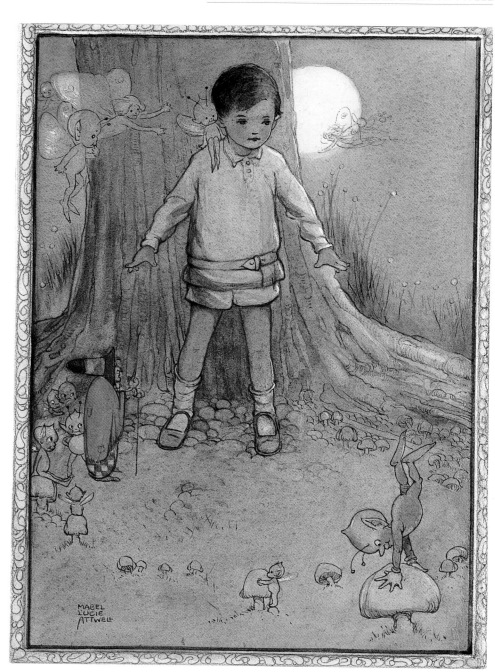

52

I PITY THE CHILDREN - WHO
FAIRY CAN FIND

signed
inscribed with title and 'Billy Boys
Train' on reverse
watercolour with bodycolour
9 x 6 ½ inches

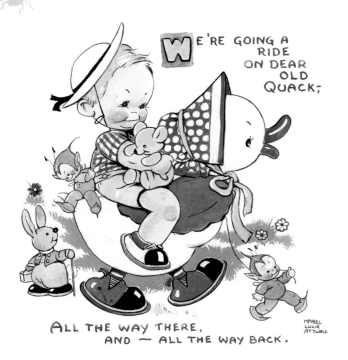

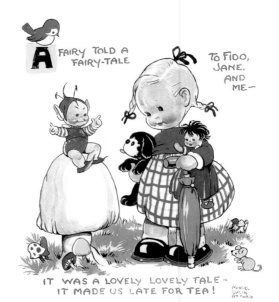

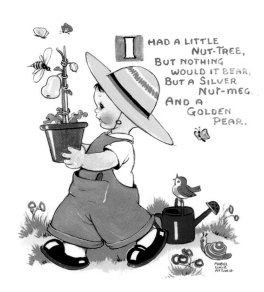

53

WE'RE GOING A RIDE ON DEAR
OLD QUACK;
ALL THE WAY THERE.
AND — ALL THE WAY BACK.
signed
pen ink and watercolour
11 x 9 inches

54

A FAIRY TOLD A FAIRY-TALE
TO FIDO, JANE, AND ME —
IT WAS A LOVELY LOVELY TALE —
IT MADE US LATE FOR TEA!
signed
pen ink and watercolour
11 x 9 inches
Design for towelling bibs and feeders, Messrs
Higham-Tong Ltd, 1964

55

I HAD A LITTLE NUT-TREE,
BUT NOTHING WOULD IT BEAR,
BUT A SILVER NUT-MEG,
AND A GOLDEN PEAR.
signed
pen ink and watercolour
10 ½ x 9 inches
Design for towelling bibs and feeders, Messrs
Higham-Tong Ltd, 1964

56

WOMEN - THEY'RE ALL ALIKE, OLD
CHAP!

signed

watercolour with bodycolour

8 ½ x 12 ½ inches

Provenance: the Estate of Mabel
Lucie Attwell

57

ANOTHER LITTLE 'BIFF' WON'T DO
HER ANY HARM

signed

watercolour with bodycolour

12 x 8 ½ inches

Design for a postcard no 4816,
for Valentine of Dundee, 1919

Provenance: John Henty

Literature: John Henty, *The
Collectable World of Mabel Lucie
Attwell*, London: Richard Dennis,
1999, page 42

Exhibited: *Mabel Lucie Attwell
Retrospective*, Langton Gallery,
no 69

58

THE WORLD MAY BE FULL OF
WORRY, BUT THERE IS SOMETHING
NICE TO WEAR

signed

inscribed with title on reverse

watercolour with bodycolour

11 x 7 inches

Provenance: the Estate of Mabel
Lucie Attwell

61

BIG GREEN EYES LOOKING UP AT YOU

signed with initials

watercolour with bodycolour

10 x 8 ½ inches

Provenance: the Estate of Mabel Lucie Attwell

62

LONESOME WITHOUT YOU

signed

watercolour with bodycolour

13 x 9 inches

Provenance: the Estate of Mabel Lucie Attwell

59

QUESTIONING ONE'S REFLECTION

signed

watercolour with bodycolour

15 x 11 ½ inches

Provenance: the Estate of Mabel

Lucie Attwell

60

HAPPY DAYS

signed

inscribed with title on reverse

watercolour with bodycolour

12 x 7 ½ inches

Provenance: the Estate of

Mabel Lucie Attwell

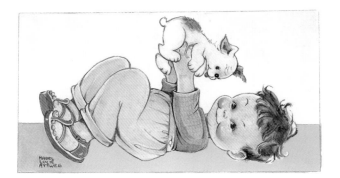

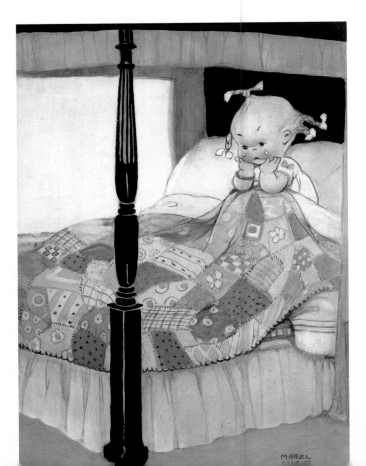

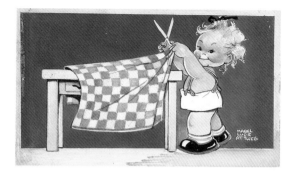

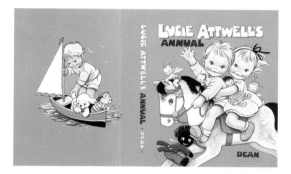

65

GOD BLESS OUR 'LEVENSES!

signed

inscribed with title on reverse

watercolour with bodycolour

12 x 9 inches

Design for a postcard no 1437, for Valentine of Dundee.
Mabel Lucie Attwell Calendars, 1950 and 1951
Provenance: the Estate of Mabel Lucie Attwell
Literature: John Henty, *The Collectable World of Mabel Lucie Attwell*, London: Richard Dennis, 1999, page 76

63

CAN'T HAVE A TABLECLOTH AND A SHIRT!

signed

inscribed with title on reverse

watercolour with bodycolour

6 ½ x 10 ½ inches

Design for a postcard no 755, for Valentine of Dundee
Provenance: the Estate of Mabel Lucie Attwell
Literature: John Henty, *The Collectable World of Mabel Lucie Attwell*, London: Richard Dennis, 1999, page 71

64

LUCIE ATTWELL'S ANNUAL, FRONT AND BACK COVERS

inscribed with title on reverse and dated 1961

watercolour with bodycolour

13 x 20 inches

Provenance: the Estate of Mabel Lucie Attwell
Illustrated: *Lucie Attwell's Annual*, London: Dean, 1961, front and back covers

66

NOW WE'VE BEEN AND GONE AN' DONE IT!

signed

inscribed with title on reverse

watercolour with bodycolour

10 ½ x 7 ¼ inches

Design for a postcard no 5366, for Valentine of Dundee
Provenance: the Estate of Mabel Lucie Attwell
Literature: John Henty, *The Collectable World of Mabel Lucie Attwell*, London: Richard Dennis, 1999, page 114

JOHN AND ISOBEL MORTON-SALE

John Dalton Morton-Sale (1901-1990)

Isobel Laurie Morton-Sale (née Lucas) (1904-1992)

Nos 67–76:
Provenance: the Estate of John
and Isobel Morton-Sale

John Morton-Sale was born in Kensington, London on 29 January 1901. He made the decision at an early age to become an artist, but his parents encouraged him instead to begin a career in the civil service. He tried the work for a couple of years, but then persuaded his parents to allow him to study art. He went first to the Putney School of Art, and then to the Central School of Art, where he met Isobel Lucas, who later became his wife.

Isobel Lucas was born in Chelsea, London on 15 May 1904. At the age of seven she moved with her family to Kew. Three years later, on the outbreak of the First World War, Isobel's parents moved again, to Broadstairs, Kent, and Isobel was sent to a convent at Blundell Sands on Liverpool Bay. After another three years, she was educated privately in Broadstairs. On finishing her general education, she attended the Margate and Ramsgate Art School before moving to the Central School in London.

At the Central School of Art, John and Isobel both studied under A S Hartrick and Spenser Pryse, Isobel also taking lessons from Noel Rooke. At the time of their engagement in 1920, John and Isobel were developing similar skills and contemporary approaches, so that when they graduated, and married in 1924, their talents fitted hand in glove.

At an early stage in his career, John was approached by Percy Hodder Williams of Hodder and Stoughton, a publisher with a high reputation in art reproduction. John's experience of working with Hodder and Stoughton greatly supplemented his artistic education and helped inspire his later creation of the Parnassus Gallery.

John's illustrations to *Good Afternoon, Children*, published in 1932, reveal his determination to establish himself as both versatile and individual. In order to match the range of the 'wireless stories' and plays from *The Children's Hour*, he employed marginal sketches,

full-page drawings and colour plates, and appropriated a number of visual styles. In the volume, he reworked the approaches of illustrators as diverse as Kay Nielsen and E H Shepard.

If Isobel seemed to put aside her career to care for her new daughter, Roysia, she actually found inspiration in the experience and made extensive studies of the child. When she returned to her regular work, the studies provided excellent sources of reference for her paintings and illustrations. In 1936, she and John made their first complete collaboration, on the illustrations to *The Yellow Cat* by Mary Griggs. In the same year, Sir Robert Lusty of the publishers Michael Joseph, introduced the Morton-Sales to Eleanor Farjeon, in the belief that they would make the perfect choice of illustrators for her latest book, *Martin Pippin in the Daisy Field*. When the resulting volume appeared in 1937, it met with great success and so sealed the friendship and partnership between artists and author. *Sing for your Supper*, their second joint venture, was published in 1938.

In 1937, the Morton-Sales moved from London to an ancient long-house on the edge of Dartmoor, in Devon. When the Second World War broke out, John and Isobel continued to work as painters and illustrators. As a contribution to the war effort, they produced a painting of *The Red Cross of Comfort* for *The Queen's Book of the Red Cross* (1939). It was reproduced alongside images by some of the most admired of British artists, such as Frank Brangwyn, William Russell Flint and Laura Knight.

During this time, their pattern of life, punctuated with visits from authors, resulted in some of their best-loved books. The trio of volumes produced with Eleanor Farjeon, and later collected as *Then There Were Three* (1958) began early in the 1940s at the suggestion of the Morton-Sales. *Cherrystones* (1942) the first of the

three, was dedicated to their daughter, Roysia. In 1943, Beverly Nichols stayed nearby to write *The Tree That Sat Down*, and the Morton-Sales provided the illustrations.

About the same time, the Morton-Sales became close friends of the writer Elizabeth Goudge, who was living near Paignton on the South Devon coast. On one visit to their home, she saw a number of Isobel's latest paintings of children and was inspired by them to write a group of four stories. When these were published by the Parnassus Gallery in 1964, they were each accompanied by a black and white illustration drawn by Isobel.

The final book illustrated by the Morton-Sales together was *Something Particular* (1955). In the post-war period, ballet had

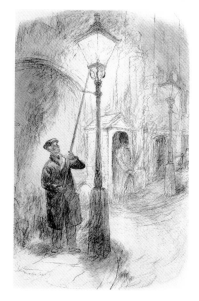

gained in popularity, and this 'venture by children in mime, music and dance' was based on classes devised, in 1949, for the Princes of Gloucester and Kent, and was published at a high point of royal popularity. The Morton-Sales attempted a visual expression of the enlightened educational ideas of Rosalind Ramirez, a royal tutor, and Ann Driver, musician and broadcaster.

The Morton-Sales ceased to work as illustrators soon after they transferred their main interest from creating an image to disseminating it. John had long wanted to apply his knowledge of colour reproduction to the publication of fine art prints. So, in 1952, he and Isobel founded the publishing house known as the Parnassus Gallery. Based at the barns at Slocombe, the company grew in a quarter

67 – John Morton-Sale
THE LAMPLIGHTER WIELDED HIS LONG POLE AND LIGHTED THE BIG CROWN-TOPPED LAMPS FOR THE NIGHT
signed
watercolour and charcoal
18 ½ x 12 inches
Illustrated: Ann Driver and Rosalind Ramirez, *Something Particular*, London: Hodder & Stoughton, 1955, page 13

of a century to employ a staff of fifteen, and to serve clients in countries as far afield as Switzerland and the United States.

John was credited with a keen eye for judging the form and colour of both the original objects and their reproduction. Isobel was praised for her concise accompanying descriptions. Initially they reproduced a number of their own paintings, but they made their mark by seeking out important, if little-known or rarely-seen, works of art held in collections throughout Britain and Europe.

Early on came a request from the Royal Academy wishing to open a card department with Parnassus cards. Later, John Pope Hennessy, Director of the Victoria and Albert Museum, praised the cards of the Parnassus Gallery as the most beautiful he had ever

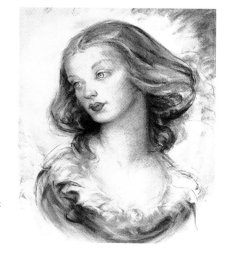

68 – John Morton-Sale
PORTRAIT OF A YOUNG WOMAN
watercolour and charcoal
17 x 12 ¾ inches

seen, and invited John and Isobel to produce the first greetings cards ever to be stocked by the museum.

In 1977, the Morton-Sales retired from the Parnassus Gallery, but even then continued to draw and paint. John had exhibited regularly at the Leicester Galleries from early in his career, and Isobel showed work at the Royal Society of Portrait Painters in the years 1979, 1980, and 1983. In 1984, they shared a painting retrospective at the Maas Gallery, London. Though John was unable to attend the opening, he took pleasure in seeing it hung. He died at Chagford, Devon on 14 March 1990. Isobel died two years later, at Moretonhampstead on 25 November 1992.

Further reading: David Wootton, *John & Isobel Morton-Sale*, London: Chris Beetles Ltd, 1996

JOHN MORTON-SALE

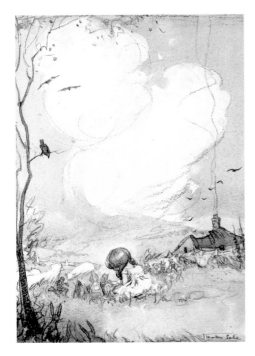

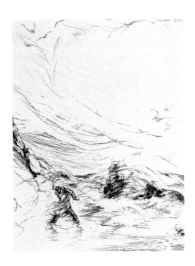

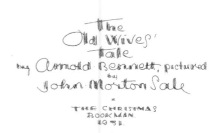

69

BUTTER'S CHEAP IN FAIRYLAND

signed

watercolour with charcoal and bodycolour

11 x 7 ½ inches

Illustrated: Will H Ogilvie, *A Clean Wind Blowing*,
London: Constable, 1930, facing page 40

70

HE ROSE TO HIS FEET BLINDLY AND BALANCED
HIMSELF AGAINST THE GALE

charcoal

17 x 12 inches

Illustrated: John Buchan, *The Magic Walking Stick*,
London: Hodder & Stoughton, 1932, page 158

71

THE OLD WIVES' TALE

signed with initials and inscribed
with title

charcoal

17 x 10 inches

Illustrated: Arnold Bennett,
The Old Wives' Tale, London: The
Christmas Bookman, 1931, front
cover

72

LONDON BOMBED

signed

signed and inscribed with title below
mount

pen ink and watercolour

13 ½ x 11 inches

ISOBEL MORTON-SALE

73

UMBRELLA

signed

watercolour and charcoal with bodycolour

15 x 13 inches

74

HOT CHESTNUTS

signed

watercolour with charcoal

9 ½ x 9 ½ inches

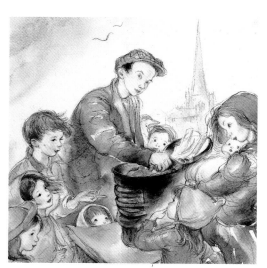

75

THE MERRY-GO-ROUND

signed

watercolour with charcoal

10 ¾ x 11 inches

76

INVITATION TO SWIM

signed twice

watercolour with bodycolour

13 ½ x 10 inches

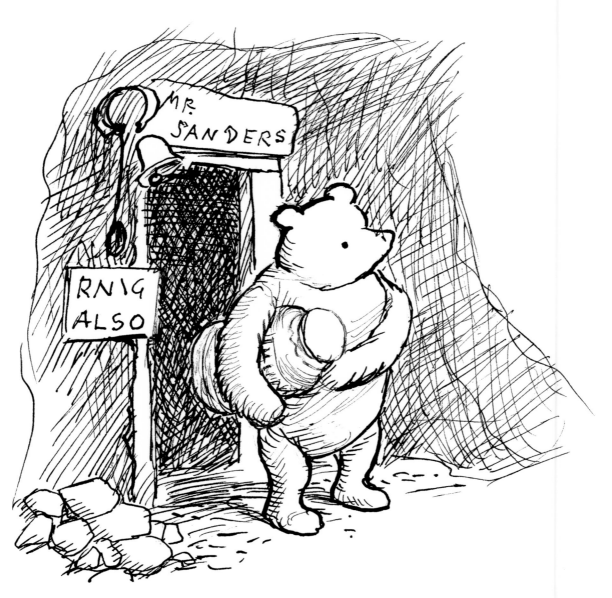

ERNEST HOWARD SHEPARD

Ernest Howard Shepard, MC OBE (1879-1976)

77 – left

WINNIE-THE-POOH AND THE
HUNNY-POT

signed and dated 1966

*signed with initials, inscribed 'replica
drawing' and dated 'July 1966' on
reverse*

pen and ink with pencil

5 ¼ x 4 ¼ inches

78

WE WERE SPRAWLING ON
THE LAWN

signed with initials

*signed and inscrbed with title and
artist's address on reverse*

pen and ink

4 ¾ x 11 ½ inches

Illustrated: Kenneth Grahame, *The
Golden Age*, London: John Lane at
the Bodley Head, 1928, pages 90-91

For a biography, refer to *The Illustrators*, 1999, page 150; for essays
on various aspects of the artist's achievement, refer to *The
Illustrators*, 1999, pages 151-152; and *The Illustrators*, 2001,
pages 28-32

Key works illustrated: Contributed to *Punch* from 1907, becoming second cartoonist
in 1935, and chief cartoonist from 1945-1949; A A Milne, *When We Were Very Young*
(1924); E V Lucas, *Playtime and Company* (1925); A A Milne, *Winnie-the-Pooh* (1926);
Everybody's Pepys (1926); *The House at Pooh Corner* (1928); Kenneth Grahame, *The Wind
in the Willows* (1931); Richard Jeffries, *Bevis* (1932); E V Lucas, *As the Bee Sucks* (1937)

His work is represented in the collections of the British Museum, the Victoria and
Albert Museum and the Shepard Archive at the University of Surrey.

Further reading: Rawle Knox (editor), *The Work of E H Shepard*, London: Methuen, 1979

79

STAYED HIM WITH CHUNKS OF COLD PUDDING

signed with initials

signed, inscribed with title and artist's address on reverse

pen and ink

7 ½ x 8 inches

Illustrated: Kenneth Grahame, *The Golden Age*, London: John Lane at the
Bodley Head, 1928, page 44

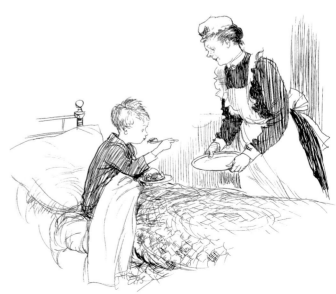

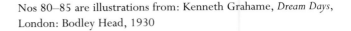

Nos 80–85 are illustrations from: Kenneth Grahame, *Dream Days*, London: Bodley Head, 1930

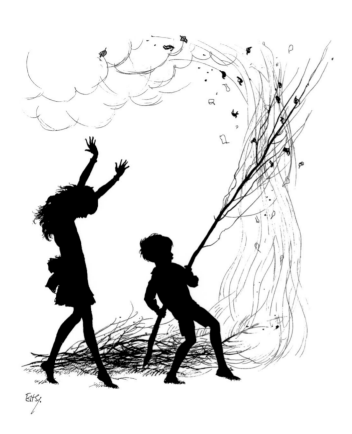

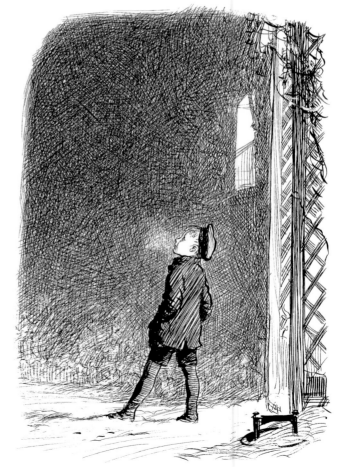

80

SELINA A MAENAD NOW HATLESS
AND TOSSING DISORDERED LOCKS,
STALKED AROUND THE PYRE
signed with intials
signed, inscribed with title, artist's
address and 'Dream Days' on reverse
pen and ink
8 ¾ x 7 inches
Illustrated: *Dream Days*, page 14

81

BUT I LINGERED A MOMENT — IN
THE STILL FROSTY AIR
signed, inscribed with title, artist's
address and 'Dream Days' on reverse
pen and ink
9 ¾ x 6 ¾ inches
Illustrated: *Dream Days*, page 149

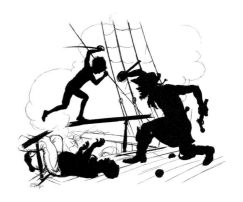

82

HUNT THEM AS BISONS
signed with intials
signed, inscribed with title, artist's
address and 'Dream Days' on reverse
pen and ink
6 ½ x 9 inches
Illustrated: *Dream Days*, page 25

83 (below left)
BUT ALL THE SAME YOU GIVE
THEM A GOOD TALKING
signed
signed, inscribed with title, artist's
address and 'Dream Days' on reverse
pen and ink
9 x 14 inches
Illustrated: *Dream Days*, page 27

84 (below right)
AND MADE CAPTURE OF HIM
signed with intials
signed, inscribed with title, artist's
address and 'Dream Days' on reverse
pen and ink
8 x 7 inches
Illustrated: *Dream Days*, page 17

85

I REACHED THE QUARTER DECK
AND CUT DOWN THE PIRATE
CHIEF
signed with initials
signed, inscribed with title, artist's
address and 'Dream Days' on reverse
pen and ink
6 ½ x 6 ½ inches
Illustrated: *Dream Days*, page 98

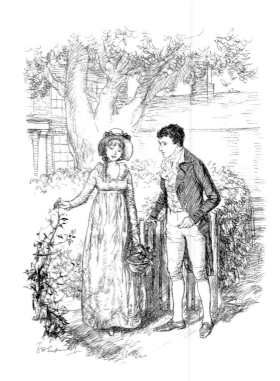

86

THE MUTTON WAS BAD

signed

signed, inscribed with title and
'Everybody's Boswell' on reverse

pen and ink

8 ½ x 12 ¼ inches

Illustrated: F V Morley (editor),
Everybody's Boswell, London: G Bell
and Sons, 1930, facing page 414

87

WHEN I WAS IN THRALL TO
THE FAIR AND FAIRER EYES OF
ALICE WESTON

signed

signed, inscribed with 'Everybody's
Lamb, When I was in Thrall' on reverse

pen and ink

13 x 9 inches

Illustrated: A C Ward (editor),
Everybody's Lamb, London: G Bell
and Sons, 1933, page 351

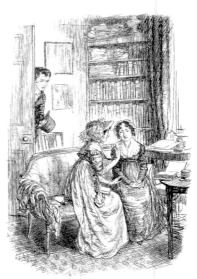

88

I JUST CAME IN TIME

signed

inscribed with 'Lamb Essays, Vows of
Eternal Friendship' on reverse

pen and ink

10 x 7 inches

Illustrated: A C Ward (editor),
Everybody's Lamb, London: G Bell
and Sons, 1933, page 133

89

THE TREE

signed

pen and ink

12 ¾ x 10 inches

Enclosing a poem by Evoe (E V Knox)

Illustrated: *Punch*, 6 January 1954, page 49

The picture appeared in *Punch* without Toby, the dog. An editorial note below the artwork explains this omission – 'if necessary this can be lowered or cut out, should verse be too long'.

90

HARRISON'S FARM

signed and inscribed with title and poem

pen and ink

2 images each 11 ¾ x 9 inches

Enclosing a poem by Mary Child

Illustrated: *Punch*, 27 July 1949, pages 100-101

92

IMAGINARY CONVERSATIONS
'NEGUS MY HEART IS SOFTENED.
I HAVE DECIDED TO REPOPULATE
YOUR COUNTRY WITH OUR OWN
MAGNIFICENT JEWS.'
[IT IS SAID THAT SIGNOR MUSSOLINI
INTENDS TO FIND A PLACE IN
ETHIOPIA FOR THE JEWS WHO ARE
BEING EXILED FROM ITALY]
pencil
10 ½ x 8 ½ inches
Preliminary drawing for *Punch*,
14 September 1938, page 285

94

PUNCH – SUMMER NUMBER
COVER DESIGN
crayon with pencil
12 x 10 inches

91

THICKER THAN WATER
'NOW, SAM, STEP ON IT.'
signed and inscribed with title
signed and inscribed with artist's
address on reverse
pen and ink
12 x 9 ¼ inches
Illustrated: *Punch*, 19 June 1940,
page 661

96

THE TRANSATLANTIC UMBRELLA
'THERE SEEMS TO BE A
CONSTITUTIONAL OBJECTION TO
OPENING IT RIGHT OUT'
signed and inscribed with title
signed and inscribed with artist's
address on reverse
pen ink and crayon
12 x 9 inches
Illustrated: *Punch*, 23 February
1949, page 203

93

WINNING PIECES'
...A MORE NEARLY GLOBAL STRENGTH
AT SEA THAN THE WORLD HAS
EVER SEEN' (MR CARL VINSON)
signed and inscribed with title
signed and inscribed with artist's
address on reverse
pen and ink
13 x 10 inches
Illustrated: *Punch*, 30 September
1942, page 267

95

TROUBLE WITH SOME OF THE
PIECES
signed and inscribed with title
signed and inscribed with artist's
address on reverse
pen ink and crayon
11 ½ x 9 ½ inches
Illustrated: *Punch*, 7 February
1945, page 119

GEORGE BELCHER

George Frederick Arthur Belcher, RA (1875-1947)

For a biography, refer to *The Illustrators*, 1997, pages 98-99

99

OFFICER (VISITING SENTRY): AND WHAT ARE YOUR DUTIES?
SENTRY (AFTER A FEW MINUITES HESITATION): TO PREVENT ANY UNAUTHORISED
PERSON FROM ENTERING
GOVERNMENT PROPERTY
AND TO STOP ALL AIR
RAIDS
signed
charcoal and watercolour
11 ¼ x 16 ¼ inches
Illustrated: *Punch*,
8 December 1915,
page 467

97

PLEASE, MUM, IF THE INVASION COMES WHILE YOU'RE OUT,
WHAT ARE YOUR ORDERS?
signed
inscribed with title below mount
charcoal
13 ¼ x 13 ½ inches
Illustrated: *Punch*, 16 October 1940, page 389

98

COOK: OH MA'AM I DID ENJOY MESELF AT THE THEATRE LAST
NIGHT. THERE WAS A KITCHEN SCENE IN THE FIRST ACT AND
THEY WAS BAKIN' POTATOES IN THEIR JACKETS AND FRYING
REAL HAM SO'S YOU COULD SMELL IT ALL OVER THE
THEATRE. I NEVER ENJOYED ANYTHING SO MUCH.
signed
inscribed with title below mount
charcoal and watercolour
10 ¾ x 15 ¼ inches
Illustrated: *Punch*, 11 July 1923, page 47

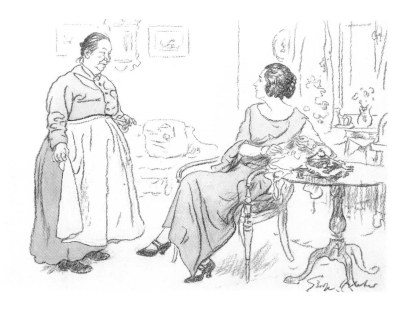

BERNARD PARTRIDGE

Sir John Bernard Partridge, RI NEAC (1861-1945)

For a biography, refer to *The Illustrators*, 1997, pages 83-84

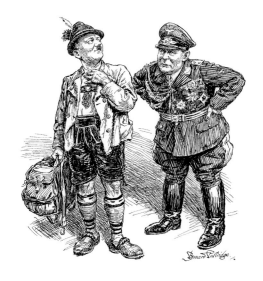

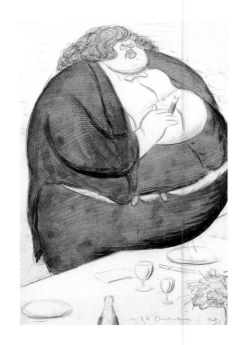

100

AWFULLY ARRAYED

GOERING: WHAT'S THE IDEA OF THE FANCY COSTUME ADOLF?

HITLER: MERELY TO BE PREPARED, I COMMITTED MY CHIEF CRIME IN

AUSTRIA: — I WAS BORN THERE.

[THE MOSCOW CONFERENCE HAS AGREED THAT WAR CRIMINALS SO

FAR AS IS POSSIBLE, MUST BE SENT FOR TRIAL TO THE COUNTRIES

WHERE THEIR CRIMES WERE COMMITTED]

signed and inscribed with title and publication details

pen and ink

13 ½ x 10 ¼ inches

pen and ink sketch, 13 ½ x 10 ¼ inches on reverse entitled:

The Mussolini Muzzle

The Dictator of Spain: That Italian silencer I've tried on him doesn't seem to

have much effect on his hind legs

Illustrated: *Punch*, 10 November 1943, page 397

101

MEN WHO MATTER. BY MAX.

NO XII.

MR G K CHESTERTON

signed and inscribed 'Mr G K

Chesterton'

watercolour with pencil

11 ¾ x 8 ½ inches

Similar to the *Bystander*, 24 July

1912, page 187, owned by the

Ashmolean Museum, Oxford,

and recorded in Rupert

Hart-Davis, *A Catalogue of the*

Caricatures of Max Beerbohm,

London: Macmillan, 1972,

no 312

102 (above right)

ROBERT TABER

signed and inscribed with title

pen and ink

9 ¾ x 7 ¼ inches

Provenance: Eva Reichmann

Literature: Rupert Hart-Davis,

A Catalogue of the Caricatures of

Max Beerbohm, London:

Macmillan, 1972, no 1651

Robert Taber (1866-1904) was

an actor.

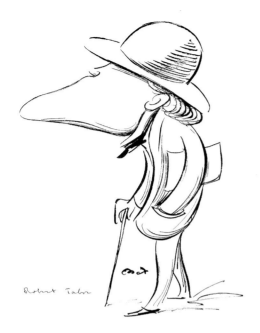

MAX BEERBOHM

Sir Henry Maximilian Beerbohm, IS NEAC PS (1872-1956)

For a biography, refer to *The Illustrators*, 1997, page 154

Further reading: Lord David Cecil, *Max*, London: Constable, 1964; Rupert Hart-Davis, *Catalogue of the Caricatures of Max Beerbohm*, London: Macmillan, 1972; Rupert Hart-Davis (editor), *Letters of Max Beerbohm 1892-1956*, London: John Murray, 1988; Rupert Hart-Davis (editor), *Max Beerbohm, Letters to Reggie Turner*, London: Rupert Hart-Davis, 1964

His work is represented in the collections of the Tate Gallery, the Victoria and Albert Museum, the Ashmolean Museum, the University of Princeton and the University of Texas.

Prime Ministers from right to left: Disraeli, Gladstone, Salisbury, Rosebery, Balfour, Campbell-Bannerman, Asquith, Bonar Law, Lloyd George, MacDonald, Baldwin, Chamberlain, Churchill

103

PRIME MINISTERS IN MY TIME

signed with self-portrait and inscribed 'for Oscar and Gloria — with Max's love — Prime Ministers in my time — some of them even in Oscar's time too; fewer of them in Gloria's — Abinger — 1944'
pencil and watercolour
10 x 15 ½ inches
Provenance: Oscar Pio
Similar to Rupert Hart-Davis, *A Catalogue of the Caricatures of Max Beerbohm*, London: Macmillan, 1972, no 439

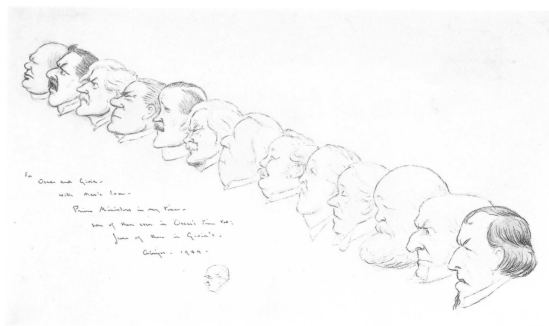

FRANK REYNOLDS

Frank Reynolds, RI (1876-1953)

For a biography, refer to *The Illustrators*, 1997, page 99

104

THE PARADE

signed

watercolour and bodycolour

4 images each 3 ¾ x 9 inches

Illustrated: *Punch,* Summer Number, 1921, [unpaginated],
'Eighty Years of Change'

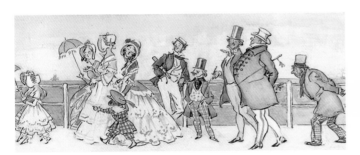

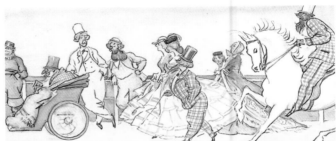

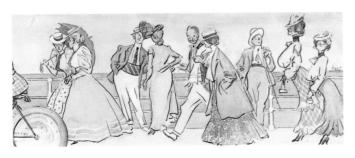

LAWSON WOOD

Clarence Lawson Wood, RI (1878-1957)

For a biography, refer to *The Illustrators*, 1997, page 101

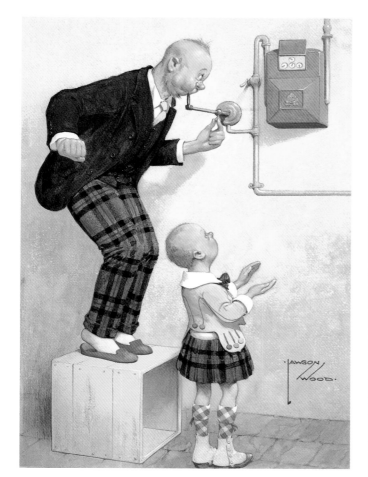

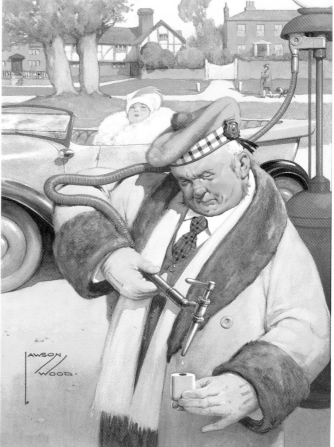

105
'ALL SCOTCH' NO 6
'ALL SCOTCH' THRIFT. A BAG-PIPE
CHAMPION REDUCING HIS
GAS BILL
signed and dated 23
inscribed with title on reverse
watercolour and bodycolour
14 x 10 inches

106
'ALL SCOTCH' NO 4
THE 'ALL SCOTCH' SPIRIT
signed
inscribed with title on reverse
watercolour and bodycolour
14 ¼ x 10 ¼ inches

CHARLES HENRY CHAPMAN

Charles Henry Chapman (1879-1969)

For a biography, refer to *The Illustrators*, 1999, page 203

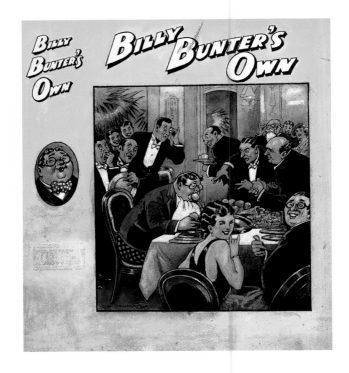

107

MOSSOO'S DOUBLE

pen ink, watercolour and bodycolour

12 x 8 inches

Illustrated: *Magnet*, 24 July 1937,

front cover

William Wibley, 'President and
chief moving spirit of the Remove
Dramatic Society', disguises
himself as Monsieur Charpentier,
the Greyfriars french master,
known as 'Mossoo'.

108 (above right)

BILLY BUNTER'S OWN

signed

inscribed with 'Bunter cover' on reverse

pen ink and watercolour with

bodycolour

16 x 14 ½ inches

109

BILLY BUNTER IN MANY MOODS

signed and inscribed with title

signed and inscribed with title on

reverse

pen and ink

25 ¼ x 15 ¼ inches

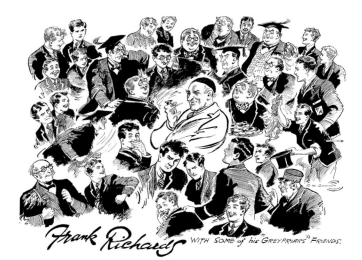

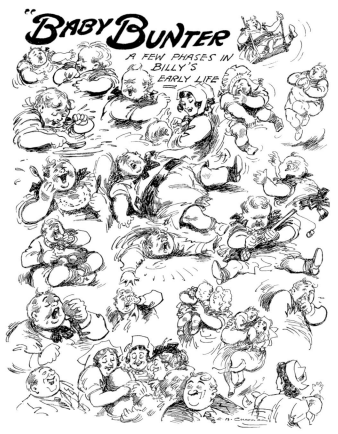

110

FRANK RICHARDS WITH SOME OF HIS
'GREYFRIARS' FRIENDS
signed and inscribed with title
inscribed with 'the chief characters at Greyfriars
School' on reverse
pen and ink with bodycolour
11 x 14 inches
Left to right: Johnny Bull, Wibley,
Mr Quelch (form master), Trotter (the page),
Dicky Nugent, Hurree Singh, Mr Prout
(form master), Squiff, Snoop, Skinner,
Vernon-Smith, Dr Locke (Head), Harry
Wharton, Peter Todd, Mark Lindley, Kipps,
Gosling (porter), Mr Hacker (form master)

111

BUNTER CROSSES THE ROAD
LOOKS LEFT — THEN RIGHT — DASHES ACROSS
— & THEN SLIPS UP ON A BANANA SKIN!
inscribed with title
signed on reverse
pen and ink
6 ½ x 17 ½ inches

112

BABY BUNTER
A FEW PHASES IN
BILLY'S EARLY LIFE
signed
inscribed with title
signed and inscribed 'Billy
Bunter's Babyhood' on
reverse
pen and ink
14 x 10 ½ inches

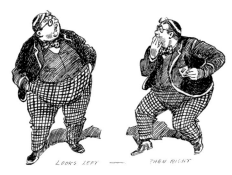

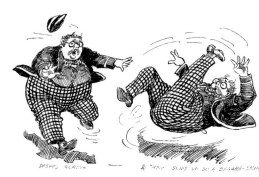

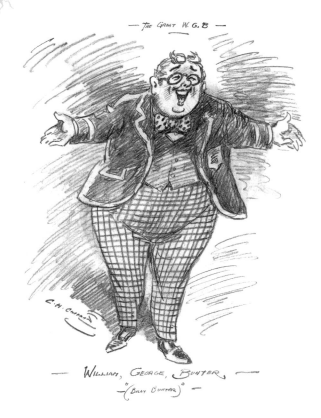

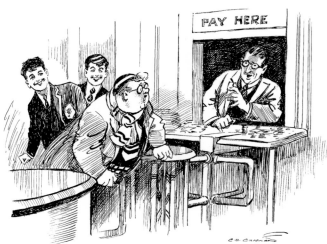

113
THE GREAT W G B
WILLIAM GEORGE BUNTER — 'BILLY
BUNTER'
signed and inscribed with title
signed and inscribed 'Billy Bunter' on
reverse
pencil
19 x 14 ½ inches

114
BUNTER'S WONDERFUL WHEEZE
OFFICIAL: TRY SIDE-WAYS, SIR
BUNTER: I HAVEN'T GOT A
SIDE-WAYS
signed
inscribed with title
pen and ink
8 ¼ x 10 ½ inches

115
THE BARON BUNTER DE BUNTER
inscribed with title and the parodic
signature 'H Skinner 1753 pinxit'
signed and inscribed
'Great historical discovery
echo of a coronation
Baron Bunter de Bunter
at the coronation of George I circa 1753
discovery of a valuable portrait
found in the vaults of Bunter Castle
the painting was by a grate artist
200 years ago
dug up June 2nd 1953' on reverse
pen ink and watercolour
11 ¼ x 9 inches

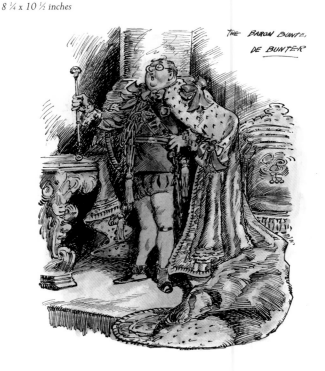

FRANK MINNITT

Frank J Minnitt (1894-1958)

From the 1920s to the late 1950s Frank Minnitt drew for well over one hundred comic papers but today he is remembered almost entirely for his exuberant Billy Bunter strips in the *Knockout*. Frank began to draw Bunter for this Amalgamated Press weekly in 1939 and, apparently without missing an issue, continued the strip to the time of his death almost twenty years later.

He was born in London on 3rd September 1894 and educated at the Hugh Middleton School in Camberwell. There is no record of any of his illustrations being published before the First World War during which he served in the Coldstream Guards and, on active service in France, suffered injuries from mustard gas attacks.

He married twice, in 1921 and in 1950. He and his first wife, Alice, had a daughter, and his second marriage, to Evelyn, produced a son.

It was some time after the end of the First World War that Frank became established as an illustrator. He had several different jobs before a few of his single frame cartoons were accepted for publication. By 1927 he was drawing for the Amalgamated Press's *Butterfly* and *Illustrated Chips*, and a year or two later, contributing strips to the same publisher's *Jester* and *Joker*.

Illustrations in his distinctive rounded style (which was later used to brilliant effect in his Bunter drawings) never occupied prominent positions in these and other comics which published his work in the 1920s and early 30s. In 1936 he successfully approached D C Thomson, the Scottish publisher whose boys' weeklies were then threatening the circulation of the London based Amaglamated Press papers, and began to draw for the Fun Section of the *Sunday Post* newspaper. He also contributed to Thomson's first – and still running – weekly comic paper, the *Dandy* drawing 'Sam and his Sister' in 1937 and 'Flippy the Sea Serpent' in 1938.

However, it was the Amalgamated Press's response to Thomson's *Dandy* and its companion paper *Beano* that was to provide Minnitt with his great opportunity. The Amalgamated Press launched the *Knockout* in 1939 which echoed the slapstick style of Thomson's two extremely successful comics. The Amalgamated Press's long running boys' story paper *Magnet* had for thirty years featured the compelling stories of Greyfriars School by Charles Hamilton (Frank

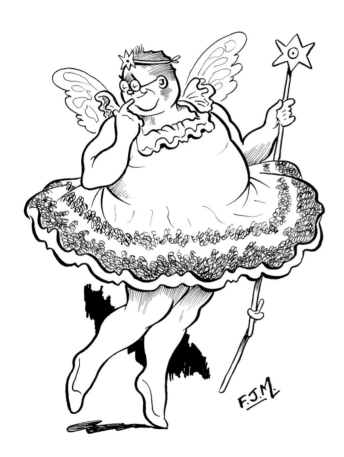

116

B... AS A FAIRY

signed with initials

pen and ink

10 x 7 inches

Richards) in which, of course, Billy Bunter was the star. Although the *Magnet* generally carried stories with only a few illustrations, its regular artist C H Chapman had drawn a few picture strips for it featuring Bunter and his schoolmates. These proved so popular that Chapman was asked to draw a two page Greyfriars strip for the new paper, *Knockout*. He did so, with little deviation from the style he had established so skilfully in the *Magnet*, but soon found himself unable to cope with the volume of work demanded by both weeklies. So, after only nine weekly instalments, a new artist had to be found for the *Knockout* Bunter strip. Several illustrators were tried and Minnitt got the job.

At first he consciously emulated Chapman's style but soon began to introduce his own versions of the established characters. The strip became more rumbustious and therefore more appropriate to the 'funnies' style of the *Knockout*. Bunter became shorter and fatter than ever while his long suffering form master, Mr Quelch, became taller, skinnier and far less dignified than in his *Magnet* appearances. Frank gradually dropped the upright and manly heroes of the Greyfriars Remove, Harry Wharton & Co, and introduced as a foil for the gargantuan and lazy Bunter the character of Jones minor who was slight, intellectual and a 'swot'.

Readers loved Minnitt's gleeful strips, and his Bunter in *Knockout* became as indelibly printed on youthful imaginations as Chapman's classic *Magnet* pictures of the fat owl of the Remove. The *Knockout* strip carried the title 'Billy Bunter, the Fattest Schoolboy on Earth': Frank drew it until he died in the summer of 1958. Other artists continued it and in 1961 the comic was renamed *Billy Bunter's Knockout*, which was surely a posthumous tribute to the never flagging vitality of Minnitt's long running version of Bunter.

In parallel with his work for *Knockout* he continued to contribute cartoons to many other comics although, despite his large output, his income was apparently a modest one. He had a long standing interest in boxing and, at the age of fourteen, had been the London Junior Boxing Champion. In later life, when he lived at Westcliffe-on-Sea, he established a Health and Sports Gymnasium there.

Mary Cadogan

Author of *Frank Richards: the Chap Behind the Chums*, London: Viking, 2000

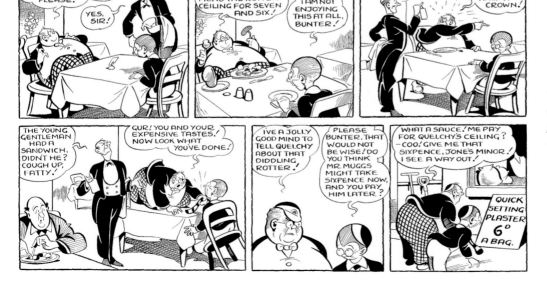

117
ONE GIANT LUNCH
pen and ink
10 x 15 ¼ inches

R J MACDONALD

R J Macdonald (died 1955)

R J Macdonald was a prolific illustrator who worked mainly for Harmsworth's (later known as the Amalgamated Press) and particularly for their boys' papers.

He began working for them in the late 1890s, illustrating some of the popular and long running 'Jack, Sam and Pete' tales in the halfpenny *Marvel*. From 1908 to 1913 he was the regular artist in the same weekly for a boxing series, and some of his early work was also used in *Pluck* and the *Magnet*.

He found his métier when in 1909 he began to illustrate the St Jim's school stories in the *Gem*. These stories were written by Charles Hamilton (using the pen name of Martin Clifford): this author was also, of course, as Frank Richards, producing the saga of Billy Bunter and Greyfriars School in the *Magnet*. Macdonald's St Jim's pictures for the *Gem* ceased during the Great War, when he seved in the Royal Naval Air Service, but apart from this gap he was the regular St Jim's illustrator from 1911 until the *Gem* ended in 1939.

His illustrations were a popular feature of most of the Amalgamated Press's *Holiday Annuals* from 1920 to 1941 for which he drew several covers and colour plates and many black and white line pictures.

There was a style and grace about Macdonald's drawings which was unusual for the boys' weekly genre. It was said that no one could portray a boy in Etons with more elegance than Macdonald, and apparently Charles Hamilton very much appreciated his

approach and considered him the best of all his illustrators. That is why he wanted Macdonald to illustrate the post Second World War Bunter books rather than C H Chapman, whose name at that time – 1947 – was the one most associated with Bunter and Greyfriars.

R J Macdonald illustrated the first seventeen of this series of hard-backed books, working on them until early in 1955 when he died at Lymington in Hampshire after being ill for some time. (C H Chapman was then asked to become the illustrator for the rest of the long running series of Bunter books.)

Macdonald's elegant schoolboys, particularly the 'swell' of St Jim's, the Honourable Arthur Augustus D'Arcy, will be long remembered. By the time he turned to drawing Bunter, the Etons had long been discarded but he gave the more modern school-boys of Bunter books something of the same style and elegance that had always characterised his work.

Mary Cadogan

118

A LATIN DICTIONARY WHIZZED ACROSS THE STUDY AND IMPINGED UPON THE FATTEST CHIN AT GREYFRIARS SCHOOL
signed
watercolour and bodycolour with
pen and ink
10 x 7 inches
Illustrated: Frank Richards, *Bunter does his Best*, London: Cassell and Company, 1954, frontispiece

EDWARD ARDIZZONE

Edward Jeffrey Irving Ardizzone,
CBE RA RDI (1900-1979)

For a biography and an essay on his illustrations to Cyril Ray's *Merry England*, refer to *The Illustrators*, 1999, pages 193-195

Key works written and illustrated: *Little Tim and the Brave Sea Captain* (1936); *Tim All Alone* (1956)

Key works illustrated: Contributed to *Radio Times* (from 1932) and the *Strand Magazine* (from 1942); H E Bates, *My Uncle Silas* (1939); *Poems of François Villon* (1946); Walter de la Mare, *Peacock Pie* (1946); Anthony Trollope, *The Warden* (1952) and *Barchester Towers* (1953); William Thackeray, *The Newcomes* (1954); Eleanor Farjeon, *The Little Bookroom* (1955); Cervantes, *Exploits of Don Quixote* (1959)

His work is represented in numerous public collections, including the British Museum, the Imperial War Museum, the Tate Gallery and the Victoria and Albert Museum.

Further reading: Brian Alderson, *Edward Ardizzone: a preliminary hand-list of his illustrated books. 1929-1970*, The Private Library, 2nd series, volume 5, No 1, 1972; Dr Nicholas Ardizzone, *Edward Ardizzone's World. The Etchings and Lithographs*, London: Unicorn Press/Wolseley Fine Arts, 2000; Gabriel White, *Edward Ardizzone*, London: Bodley Head, 1979

Nos 119–123 have the provenance of the Ardizzone family and are Illustrated in William Thackeray, *The Newcomes*, Cambridge University Press, 1954, Centenary Edition

119

LORD KEW AND THE LITTLE
GASCON
pen and ink
4 ½ x 6 ½ inches
Illustrated: *The Newcomes*,
volume i, page 334

120

THE COLONEL SINGS HIS SONG
pen and ink
4 x 6 ½ inches
Illustrated: *The Newcomes*,
volume i, page 9

121

THE COLONEL GIVES BARNES A BIT OF HIS MIND

pen and ink

4 ¾ x 6 ½ inches

Illustrated: *The Newcomes*, volume ii, page 518

THE NEWCOMES

A novel by William Thackeray, published in instalments, 1853-55

The tale centres on the family of Colonel Thomas Newcome, an unsophisticated widower, who has spent most of his life in India. His only son Clive falls in love with Ethel, whose father is the wealthy and pompous Sir Brian Newcome half-brother to the Colonel.

Ethel's brother Barnes and her grandmother Lady Kew are set against Ethel's match to Clive who is only a lowly artist. They have grander plans for her and force her into an engagement first to her cousin, Lord Kew, and, after that match is broken off, to Lord Farintosh. Despite these numerous fiancés however, Ethel remains unmarried. She has an independent spirit and is horrified by her brother's cruelty to his own wife who has eloped with her lover.

Clive is also coaxed into a reluctant marriage to Rosey Mackenzie, a pretty but frivolous girl whose mother drives the now poverty-stricken Colonel into the Grey Friars almshouse. The novel ends tragically with the death of both Rosey and the Colonel, but an epilogue suggests that Clive and Ethel finally do indeed marry and live more happily and wisely than they would have done if they had married when they first met all those years ago.

Certain aspects of Clive's character were suggested by Lord Leighton, whom Thackeray met in Rome.

Edwina Freeman

122 (far left)

BAYHAM AND PENDENNIS IN THE BUS

pen and ink

8 x 6 inches

Illustrated: *The Newcomes*, volume ii, page 611

123 (left)

EDITH AND I VISIT GREY FRIARS

pen and ink

7 ½ x 5 ¾ inches

Illustrated: *The Newcomes*, volume ii, facing page 722

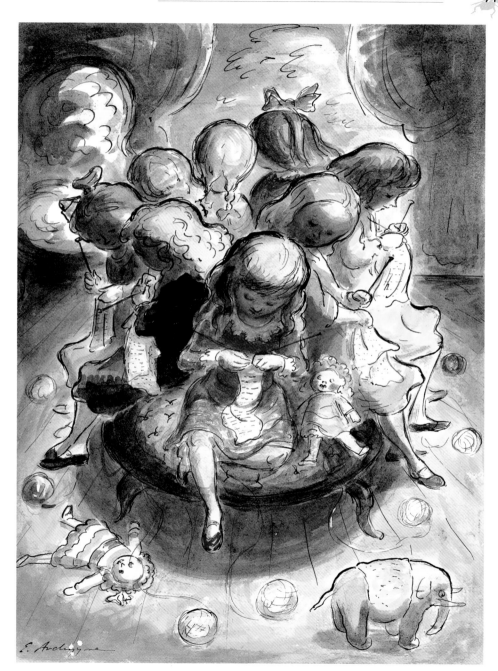

124 (left)
BATHERS
signed with initials
watercolour
7 ½ x 10 ¼ inches

125 (below far left)
THE VILLAGE PUB, RODMERSHAM
watercolour with pen and ink
9 x 11 ¼ inches
Produced circa 1929

126 (below left)
THE WATCHERS ASSEMBLED
watercolour and pencil
7 ½ x 10 ½ inches
Provenance: Mrs Catherine
Ardizzone
Literature: Gabriel White, *Edward*
Ardizzone, London: Bodley Head,
1979, colour plate iii
Exhibited: *Edward Ardizzone*, the
Scottish Arts Council Touring
Exhibition, 1979, no 83

127 (right)
KNITTING CIRCLE
signed
pen ink and watercolour
13 ½ x 9 ½ inches

ERIC FRASER

Eric George Fraser (1902-1983)

For a biography, refer to *The Illustrators*, 1997, page 162

Key works illustrated: Contributed to *Radio Times* (1926-82); Ippolito Nievo, *The Castle of Fratta* (1954)

His work is represented in the collections of the British Museum and the Victoria and Albert Museum.

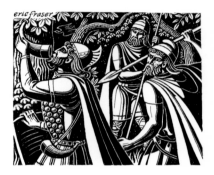

Further reading: Sylvia Backemeyer, *Eric Fraser. Designer & Illustrator*, London: Lund Humphries, 1998; Alec Davis, *The Graphic Work of Eric Fraser*, Uffculme: The Uffculme Press, 1985 (2nd edition)

128 (below left)
DAS RHEINGOLD
signed
pen and ink with bodycolour
6 ½ x 6 ½ inches
Illustrated: *Radio Times*

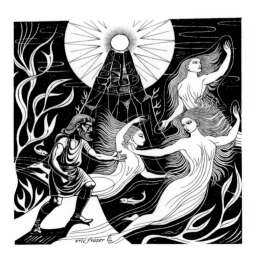

130
DIE WALKURE
signed with initials
pen and ink
4 x 4 inches
Illustrated: *Radio Times*

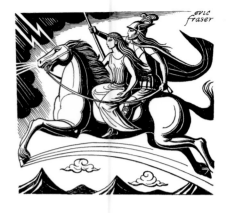

129 (left)
GOTTERDAMMERUNG I
signed with initials
pen and ink
3 ¼ x 4 inches
Illustrated: *Radio Times*

131 (below)
GOTTERDAMMERUNG II
signed with initials
pen and ink
3 x 3 inches
Illustrated: *Radio Times*

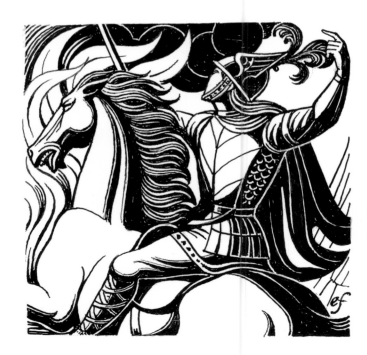

132

HEAD OF A MAN

signed

pencil

9 ¼ x 6 ½ inches

133

MOTHER AND
CHILD

*signed and inscribed
'to Esmond from
Mervyn' and dated
1950*

lithograph

15 x 8 ½ inches

Provenance:
Esmond Knight;
Mrs Nora
Swinburne

Nos 134-135 are preliminary sketches for a mural design.
During the 1930s, Mervyn Peake was commissioned by Mr and Mrs W G
Guthrie of Surrey to paint a mural of animals in naturalistic surroundings
in their conservatory.

134

SEAL

pencil

5 ½ x 7 inches

135

RHINO

pencil

5 ½ x 7 ½ inches

136

THE BIRD

signed and dated '56

watercolour

10 ½ x 15 ¼ inches

MERVYN PEAKE

Mervyn Laurence Peake (1911-1968)

For a biography, refer to *The Illustrators*, 1997, page 197

Key works written and illustrated: *Captain Slaughterboard Drops Anchor* (1939); *Ride a Cock Horse, and Other Nursery Rhymes* (1940); *Titus Groan* (1946); *Gormenghast* (1950); *Titus Alone* (1959)

Key works illustrated: Samuel Taylor Coleridge, *The Rime of the Ancient Mariner* (1943); Robert Louis Stevenson, *Treasure Island* (1949); Lewis Carroll, *Alice's Adventures in Wonderland* and *Though the Looking Glass* (1954)

Further reading: John Batchelor, *Mervyn Peake. a biographical and critical exploration*, London: Duckworth, 1974; John Watney, *Mervyn Peake*, London: Michael Joseph, 1976; G Peter Winnington, *Vast Alchemies. The Life and Work of Mervyn Peake*, London: Peter Owen, 2000; Malcolm Yorke, *Mervyn Peake: My Eyes Mint Gold: A Life*, London: John Murray, 2000

VAL BIRO

Val Biro, FSIA (born 1921)

Val Biro was born in Budapest, where he was educated by Cistercian monks. At the age of fourteen, he published his first cartoon, in *Magyar Nemzet* (Hungarian Nation), for which he received the sum of twenty pengos (the then equivalent of ten shillings). This prompted ideas of becoming a professional political cartoonist or illustrator, and he undertook initial art training in the studio of Almos Jaschik. He was then sent by his father in July 1939 to study at the Central School of Arts and Crafts in London. His teachers included Morris Kestleman, Noel Rooke, Hal Massingham, Jessie Collins and, most influentially, John Farleigh who taught him engraving. This medium was to be his greatest artistic passion and one which he would later combine with line drawing in creating his distinctive illustrations.

After the war, Biro worked for the Sylvan Press as Assistant Production Manager until, in 1946, he became Art Director for the publisher John Lehmann. He designed numerous jackets for Lehmann and produced books illustrated by John Minton, Keith Vaughan, Michael Ayrton, Philippe Julien and even Cecil Beaton.

When the company changed management in 1948, Biro turned freelance. His first commission from the *Radio Times* was *Music at Night* in 1951 and for the next twenty one years he produced regular illustrations and headings for the weekly magazine. He specialised in illustrating details of broadcast operas and also produced a number of covers. Heavily influenced by the Baroque and Rococo styles prevalent in his Hungarian heritage, his scraper-board headings are ornate and painstakingly detailed, and as such contributed greatly to the look of the *Radio Times*.

Biro has illustrated nearly four hundred books for both adults and children. Most famously he created the *Gumdrop* series of picture books which relate the adventures of a vintage motor car, based on his own Austin Clifton Heavy 12/4 1926, which he found and restored himself.

Val Biro continues to be a global-selling illustrator, writer of children's picture books, a watercolourist of architecture in landscape and a designer of commemorative medallions and coins.

Edwina Freeman

137
LOOK AT GUMDROP
signed
pen and ink on scraperboard
4 x 3 ½ inches
Illustrated: *Radio Times*
From a story by Val Biro

138
ALBERT HERRING
signed
pen and ink on scraperboard
2 ¼ x 3 inches
Illustrated: *Radio Times, 23 September 1965, page 46*
An opera by Benjamin Britten

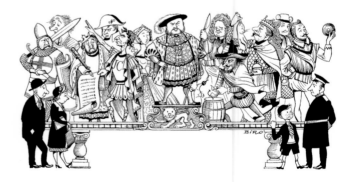

139
1066 AND ALL THAT
signed
pen and ink
3 ¾ x 7 ½ inches
Illustrated: *Radio Times*, 1 June 1951, page 27
A musical comedy based on that memorable history by W C Sellar and R J Yeatman

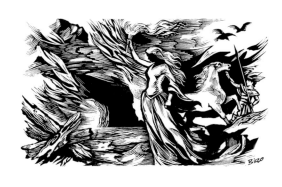

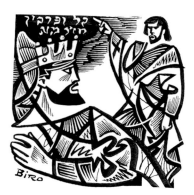

140

A SPELL FOR GREEN CORN

signed

pen and ink on scraperboard

3 ¼ x 2 ½ inches

Illustrated: *Radio Times*, 5 October
1967, page 21

A play by George Mackay Brown

142

GOTTERDAMMERUNG

signed

pen and ink on scraperboard

3 ¼ x 5 inches

Illustrated: *Radio Times, 14 October
1965, page 10*

An opera by Richard Wagner

145

BRUNNHILDE

signed

pen and ink on scraperboard

2 x 2 ¼ inches

Illustrated: *Radio Times*

From an opera by
Richard Wagner

146

BELSHAZZAR

signed

pen and ink on scraperboard

2 ½ x 2 ½ inches

Illustrated: *Radio Times, 22
September 1966, page 20*

An oratorio by Handel

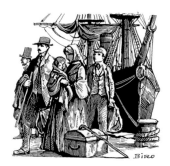

141

THE MAKING OF AMERICA

signed

pen and ink on scraperboard

3 x 3 inches

Illustrated: *Radio Times*

143

THE BASSARIDS

signed

pen and ink on scraperboard

3 ½ x 3 ¼ inches

Illustrated: *Radio Times,
19 September 1968, page 49*

An opera by Hans Werner Henze

144 (right)

THE FALL OF TROY

signed

pen and ink on scraperboard

2 ¼ x 3 ¼ inches

Illustrated: *Radio Times, 14
September 1966, page 42*

An opera by Berlioz

WALT DISNEY STUDIO

Walt Disney Studio

For an essay on the Walt Disney Studio, refer to *The Illustrators*, 1999, page 206-209

147

SNOW WHITE AND THE BLUE TIT

hand-painted cel on Covosier background

6 ¾ x 9 ¼ inches

Exhibited: Frost and Reed, 1939

SNOW WHITE AND THE SEVEN DWARVES 1937

(83 minutes)

This version of the classic fairy tale was the first ever animated feature. It received a special Oscar in 1939, and was for a while the highest grossing film to date.

HUGH CASSON

Sir Hugh Casson, PRA RIBA FSIA (1910-1999)

Three years after the death of this remarkable man he is remembered by most of the general public as a watercolourist of attractive spontaneity, and topographical charm. To the obituarists he is a polymath; multi-talented and versatile. He became an architect of significance and an inspirational teacher, a lively journalist, and a watercolourist of flair. As President of the Royal Academy, he transformed its fortunes and importance, and as an administrator he influenced every worthwhile arts organisation. To his friends and all who met him at work and at play he was a man of wit and good humour, with a remarkable lightness of approach. This engaging humanity combined with focussed energy and a steely resolve to get things done will commend him to the history books, for he was a man of achievement, and will be recalled as the mastermind behind the Festival of Britain and as the facilitating president of the Royal Academy's 'blockbuster exhibition'. 'I'm quite good at getting a lot of people, particularly artists, working together – without quarrelling that is'.

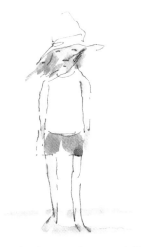

to MY VALENTINE

Hugh Casson was born in London on 23 May 1910. His father joined the Indian Civil Service after achieving a first class maths degree at Jesus College, Cambridge. His uncle Lewis Casson was the celebrated actor, director and husband of Dame Sybil Thorndike. After a degree at St John's and a three month Craven Scholarship to the British School in Athens Hugh completed his architectural education at the Bartlett School, University College London. He first worked for Christopher Nicholson (brother of Ben and son of Sir William) his Cambridge tutor in 1935. He married Margaret Troup, also an architect, in November 1938. At the start of the Second World War he joined the camouflage service of the Air Ministry and worked on disguising RAF aerodromes. He found time to teach architecture part time at Cheltenham Art School, and he started a series of life long contributions to the architectural press. In April 1944 he accepted a job at the Ministry of Town and Country Planning working on post-war planning of new towns.

After the war he returned to private practice in partnership with Kit Nicholson, but with Nicholson's premature death in a gliding accident in July 1948 Hugh Casson took on Nevil Conder to establish the successful practice of Casson Conder. This would last to his retirement in 1987 producing many high profile projects such as new buildings for Cambridge University in Sidgwick Avenue, interiors for the new SS Canberra, the Ismaili Centre at South Kensington and the acclaimed Elephant House at London Zoo (1965), nowadays housing a smaller scale superiority of phlegmatic camels.

Nos 148-164 were sent to Lady D'Avigdor Goldsmid, Casson's lifelong friend.

148	149
TO MY VALENTINE	CANAL BRIDGE TO CARCASSONE
inscribed with title	*signed with initials, inscribed with title*
watercolour with pen and ink	*watercolour with pen and ink*
5 ¼ x 3 ¼ inches	3 ¾ x 6 ¼ inches

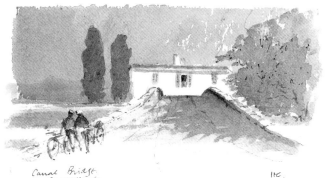

Canal Bridge
in Carcassone. HC.

FESTIVAL

Early in the Summer of 1948 Hugh Casson had a call from Gerald
Barry the Director General of the Festival of Britain asking him to
become the Director of the 1951 Festival. In accepting and in making
such a huge success of this high profile job Casson had set himself
off in a trajectory of hard work and public acclaim for the rest of
his life. 'Co-ordinating a team of more than 40 architects and
designers, Casson masterminded the transformation of 27 acres of
derelict wasteland on the South Bank. It was meant to reflect
Britain's recovery from the war and to act as a "tonic to the nation"'.

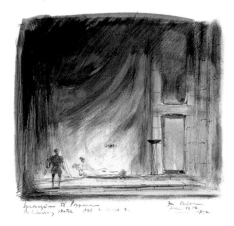

ROYALTY

From 1951 he worked on a number of projects for the royal family
including private apartments at Buckingham Palace, Windsor and
Sandringham and for the Royal Yacht Britannia. 'The overall idea
was to give the impression of a country house at sea. I think we
succeeded.' At a personal level he made life long friendships,
particularly with the Queen Mother's social circle. This culminated
in his encouraging the amateurish enthusiasms of Prince Charles'
watercolours.

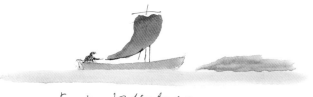

TEACHING

After the Festival he established an
Interior Design (later Environmental
Design) department at the RCA
staying there with his wife Margaret,
as senior tutor, until his retirement
in 1975.

ROYAL ACADEMY

Following the sudden death of Sir
Thomas Monnington in 1975, he
became President of the Royal
Academy; 'a role he filled with more
flair and gift for publicity than a
president of that institution had
demonstrated for decades'. The Friends of the Royal Academy was
set up in 1977 and a corporate membership scheme to give more
financial stability. The exhibition programme was extended and
commercial sponsorship soared. He is credited with the first of
many 'blockbuster' exhibitions – the Pompeii exhibition in 1977,
Post Impressionism in 1979, the *Great Japan Exhibition* in 1981, and
The Genius of Venice in 1983.

TITLES AND ACHIEVEMENTS

Fellow RIBA	1949
Elected RDI	1951
Knighted	1952
President AA	1953
Vice-President RIBA	1959
Professor of Environmental Design, RCA	1953-75
Provost RCA	1980-86
Member of the Royal Fine Art Commission	1960-1983
ARA	1962
RA	1970
PRA	1976-84

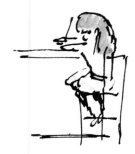

152
WRITING A LETTER
pen and ink with watercolour
3 ¼ x 3 ½ inches

150 (above left)
L'INCORONAZIONE DI POPPEA
signed and inscribed with title
watercolour with pen and ink
8 x 8 inches

151 (left)
FOR MY VALENTINE X
inscribed with title
watercolour with pen and ink
3 x 7 ½ inches

154

LITTLE GIRL

signed with initials, inscribed 'for Rosie – with love H.C.' and dated July '76
inscribed with title on reverse
watercolour with pen and ink
3 ½ x 3 ½ inches

155

FOR ROSIE WITH LOVE FOR
CHRISTMAS FROM SUMMERHILL
(FROM MEMORY!) US BOTH HUGH
& MAGGIE

inscribed with title
watercolour with pen and ink
5 x 6 ½ inches

153

FOUR VALENTINE HEARTS

4 images one inscribed 'To My Valentine x', one 'In Emergency Break Glass'
watercolour, pen ink, felt tip and crayon
4 images each measuring 2 x 2 inches

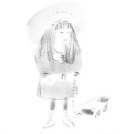

156

WAITING TO GIVE HIM HER
BOUQUET. PALERMO

signed 'from Hugh' and inscribed 'Darling Rosie much love for your birthday from both of us – a card to celebrate! Hugh x.'
pen ink and watercolour; 5 ½ x 8 inches

HUGH AND ROSIE

These 17 watercolours are from a collection of valentines and birthday cards sent by Hugh Casson to Lady D'Avigdor Goldsmid (Rosie). The D'Avigdor Goldsmids were one of a number of wealthy and influential clients such as the Cazaleis, Lord Montagu and the Sainsbury family for whom he took on residential projects in the post war years. For Rosie and her husband he extensively remodelled their large country estate, Somerhill, in Kent and later converted their country house in St Leonards Terrace. It was the beginning of a life long friendship with even the odd foreign trip taken together.

José Manser in her splendidly readable biography recalls the relationship:

> Hugh's desire to please people with gifts of his watercolours and drawings was well known. The extent of his munificence became apparent when, many years later, Rosie D'Avigdor Goldsmid showed me the bedroom in the flat where she now lived in London, every wall crowded with first-rate Casson water-colours. 'He used to give them to me as birthday presents, or to thank me for a party. I think I've got the best collection in the country. Oh, Hugh was a wonderful man, but, darling, it was no more than a loving friendship. The fact that he was never my lover made the friendship more precious.' (José Manser, *Hugh Casson A Biography*, London: Viking, 2000, pages 188-89)

Chris Beetles

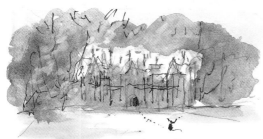

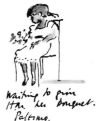

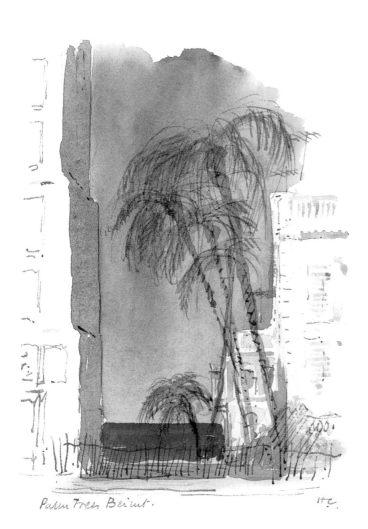

Palm Trees Beirut.

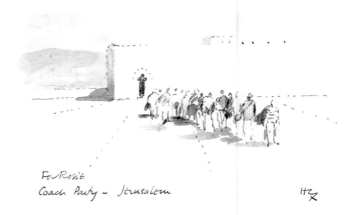

For Rosie
Coach Party — Jerusalem

158

COACH PARTY — JERUSALEM

*signed with initials, inscribed with title
and 'for Rosie'*
pen ink and watercolour
3 ¾ x 5 ½ inches

159

EN ROUTE TO THE GREAT WALL

*signed, inscribed with title and dated
1954*
pen ink and watercolour
3 x 8 ¼ inches

157

PALM TREES, BEIRUT

signed and inscribed with title
watercolour with pen and ink
6 ¼ x 4 inches

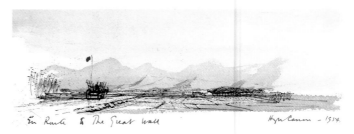

En Route to The Great Wall *Hugh Casson – 1954*

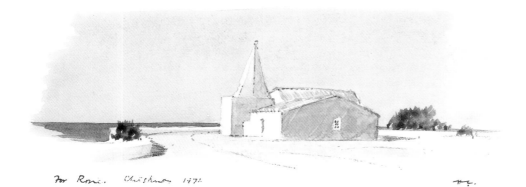

162

THE CHURCH BY THE BLUE SEA
signed with initials, inscribed 'for Rosie' and dated 'Christmas 1974'
watercolour
3 x 6 ½ inches

163 (below left)

BEDROOM, OSBORNE
signed with initials, inscribed with title and 'for Rosie' and dated 'July '77'
watercolour
4 ½ x 3 ¼ inches

164

GIRL SEATED AT A WINDOW
signed with initials, inscribed 'for darling Rosie' and dated 'Christmas '89'
watercolour with pen and ink
3 ¾ x 2 ¾ inches

160 (above)

THE TOY CART
watercolour with pen and ink
3 x 3 inches

161

CAFE CHAIRS AEGINA
signed with initials, inscribed with title and 'for Rosie with love' and dated '87
watercolour with pen and ink
5 ¼ x 3 ¼ inches

RUSSELL BROCKBANK

Russell Partridge Brockbank (1913-1979)

From Mark Bryant, *Dictionary of Twentieth-Century British Cartoonists and Caricaturists*, Aldershot: Ashgate Publishing, 2000, pages 37-38:
Russell Brockbank was born on 15 April 1913 in Niagara Falls, Canada, the son of an Englishman, Clarence Brockbank FCIC AMIE, who owned an industrial ceramics factory. Educated at Ridley College, Ontario, he studied at Buffalo School of Art, New York, and, when he went to England in 1929, Chelsea School of Art under Harold Williamson. He worked at first in his father's factory (becoming manager at the age of 19), but then began contributing to *Speed* magazine (1935-39) and by the age of 24 had become a professional artist. He served as a lieutenant with the Royal Navy Volunteer Reserve during World War II (on northern convoys and in the Pacific). A specialist in motoring and aviation cartoons, he first drew for *Punch* in 1939 and was the magazine's Art Director from 1949 to 1960. He also contributed to *Motor* (specially the famous 'Major Upsett' strip), *Commercial Motor*, *Light Car*, *Cadet Journal*, *Lilliput*, *Aeroplane*, *Road & Track*, *Automobile Jahr*, *Car Graphic* and other publications. Obsessed by cars ('I once got a D-type Jag up to 148 mph... near Godalming'), he most enjoyed drawing classic Alfa Romeos, Bugattis and Mercedes. His drawings were always completely accurate in detail and he discovered at an early age that 'you must make cars lean forward a bit and get their wheels off the ground if you want to give an impression of speed'. He used Cie Française fine nibs on Bristol board and sometimes used scraperboard. He was a member of the Savage Club and the BARC. Russell Brockbank died on 14 May 1979.

Key works written and illustrated: *Round the Bend* (1948); *Up the Straight* (1953); *Over the Line* (1955); *Bees Under my Bonnet* (with R Collier, 1955); *The Brockbank Omnibus* (1957); *Manifold Pressures* (1958); *Move Over!* (1962); *The Penguin Brockbank* (1963); *Motoring Through Punch* (1970); *Brockbank's Grand Prix* (1973)

His work is represented in the collections of the University of Kent Cartoon Centre.

Nos 165-183 are all from the Estate of Russell Brockbank

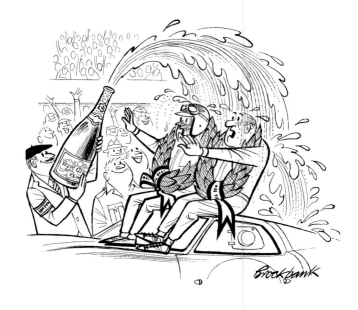

165

NO, NO — WE NEVER TOUCH THE STUFF!
signed and inscribed with title
pen and ink
7 x 7 ½ inches
Illustrated: *Motor*, 19 July 1969, page 32
Russell Brockbank, *Brockbank's Grand Prix*, London: Eyre Methuen, 1973, page 37

166

BRITISH AND PROUD OF IT:
'A HAPPY BLEND OF ITALIAN BRIO AND BRITISH COMMON SENSE, DON'T YOU AGREE SIR?'
inscribed with title
pen and ink
4 ¼ x 8 ¼ inches

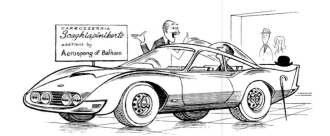

To say Brockbank is to think CARS. In cartoon art it takes a great cartoonist to become inseparable from his subject; to have that special ability that combines the qualities of idiosyncratic but accurate drawing, with a humour that explores and defines a genre.

Russell Brockbank, art editor of *Punch* from 1949 to 1960, chronicled the twentieth century's obsession with the motor car and will be forever placed in its driving seat. He is joined in this collective memory of the Age by a small and special band of artists:
• Heath Robinson (1872-1944) made the Machine Age manageable by domesticating it, and his name and inventive genius have passed into the English language.
• H M Bateman (1887-1970) recreated the ever excruciating moment of public embarrassment with the dynamic staging of that minor slip in etiquette that results in graphic overwhelming shame; the social gaffes of The Man Who… lives on in our fears.
• Pont (1908-1940) displayed the English Character and found it eccentric, … nothing changes.

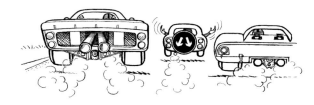

167

PASS EITHER SIDE

pen and ink

3 ¼ x 9 inches

Illustrated: *Motor*, 5 July 1969, page 45

• Giles (1916-1995) gave us The News and every fad and fashion, but gave it a sense of proportion by demonstrating the sweetly dysfunctional that lurks in every extended middle England family.

This roll call of great cartoonists is also the index to a social and psychological history of the century. The generation within which each artist worked, will recognise themselves easily enough through the jokes, insights and gentle satire but years later, despite huge political and social change, the humour is rediscovered as funny and relevant. Human nature and its preoccupations remains the same

and is revealed again and often by the rare essence of universal humour.

Brockbank knew well that his cartoons had a wider appeal than just car jokes for car nuts. In an introduction to the famously popular *Motoring Through Punch 1900-1970*, he pointed out that it 'centred on a great invention of our times which for good or ill has revolutionised the lives of us all'. There was no doubt what he personally felt about cars, for he was a happy man with his business as his hobby, never happier than driving fast on the Queen's highway, tweaking variously under the bonnet or closely mingling at Silverstone type race meetings. The resulting technical accuracy of his cars is justly acknowledged – a Brockbank Mini, Bugatti, Mercedes Benz or Rolls Royce is the real thing.

His observational skills were not, however, just chrome deep, for no one has chronicled every new development or trend with more insight. In particular throughout his work from the first cartoon for *Punch* in 1938 to the celebrated weekly cartoons for *Motor* Magazine in the 1960s and 1970s we see new alignments of the English social classes. The class struggle was no longer fought in the upstairs downstairs of country houses but on the open road between gentry and working class, sporting car enthusiasts and scattered pedestrians, between Rolls Royce and family run about, between the flash money and the stolid traveller, between the romantic and the functional.

And when internecine strife was exhausted Brockbank took the Englishman Abroad for a bit of assertive rest and recuperation. For here was the subtle renewal of our age-old relationship with the French, with the car as the new longbow and the road as the new battleground with Brockbank of course as the most impartial war correspondent.

168

DIG THOSE GROTTY MOD WHEELS ON THAT GREAT OLD VINTAGE CAR!

inscribed with title

pen and ink

5 ¼ x 6 ¾ inches

Illustrated: *Motor*

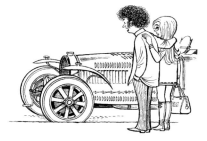

" Dig those grotty mod wheels on that great old Vintage car ! "

No nuance of driving or technical innovation escaped
Brockbank's incisive pen line. Trends and types were recorded in
the then hugely influential high circulation *Punch*, as through the
bemused and accident prone hero in the episodic adventures of
Motor magazine's Major Upsett.

Brockbank showed us how husband and wife shared the car –
a new space for battle of the sexes, and he showed us how the
countryside accommodated the cars and often fought back. We
were given hitch hiking-tramps, saluting AA men, beset bubble
cars, menacing new motorways, the first speed traps , the perils of
overtaking, caravans, bank holiday queues, motor shows and car
salesmen, the learner driver and at the other end of the rainbow
Brockbank's own pot of gold the Grand Prix moment…

> What a blessing for all mankind – except, that is, for out-
> dated hoodlums like myself who positively adore the clatter
> of overhead camshafts, the Wagnerian symphony from the
> exhaust as one slices through the gears, the smell of warm
> oil, the bite of good brakes before the screech of the tyres
> through the next corner, the arc of the rev counter needle
> racing round the dial, the whistle of the wind, the low
> moans of one's wife crouching in embryonic posture under
> the dashboard. (Russell Brockbank)

Chris Beetles

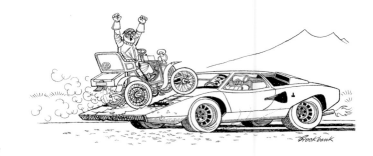

169

1903 NAPOLEON;
1974 LAMBORGHINI COUNTACH
signed and inscribed with title
pen and ink
6 ¾ x 13 ½ inches
Cartoon on reverse: illustrated in
Motor, 25 March 1967, page 35
[untitled]

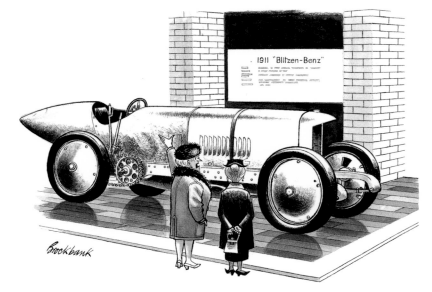

170

200 HORSEPOWER, ALL FOR ONE
SELFISH BRUTE WHO NEVER TOOK
HIS WIFE ANYWHERE
signed
inscribed with title on reverse
pen ink and monochrome watercolour
8 ½ x 12 inches

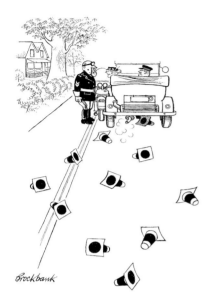

171 (right)
ON TOW
signed with initials
pen ink and monochrome
watercolour
3 ½ x 10 ¼ inches
Illustrated: *Motor*

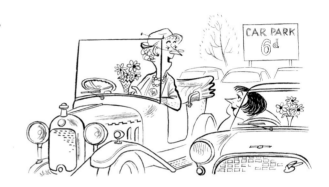

172 (left)
YOU WILL HAVE TO SPEAK UP
— WE ARE BOTH A BIT DEAF
signed with initials
pen and ink
11 ¾ x 8 ¾ inches
Illustrated: Russell
Brockbank, *The Best of
Brockbank*, London: David &
Charles, 1975, [unpaginated]

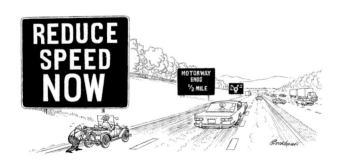

173
I DON'T KNOW ABOUT PLASTIC FLOWERS, BUT WE'VE HAD OUR
CELLULOID ONES SINCE 1926
signed and inscribed with title
pen and ink
4 ¼ x 7 inches
Illustrated: *Motor*, 5 September 1962, page 175

174
REDUCE SPEED NOW
signed
pen and ink
6 x 12 inches

175
DISC TROUBLE
signed
pen and ink
3 ½ x 9 inches
Illustrated: *Motor*, 21 January
1967, page 54

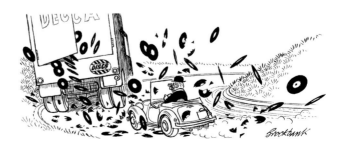

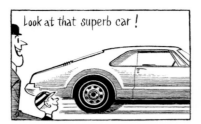 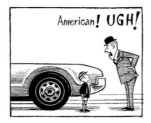

176

BRITISH AND PROUD OF IT:
LOOK AT THAT SUPERB CAR!
inscribed with title
pen and ink
3 x 8 inches

177

DO YOU MEAN TO SAY YOU AND
MOM ACTUALLY OWNED A THING
LIKE THAT ?!!
signed and inscribed with title
pen and ink
5 x 9 ¼ inches
Illustrated: Russell Brockbank, *The
Best of Brockbank*, London: David &
Charles, 1975, [unpaginated]

178

BRITISH AND PROUD OF IT
pen and ink
7 ½ x 8 ¼ inches

179

THE VERY LATEST INFORMATION ON DELIVERY IS THREE YEARS NINE
MONTHS, SIR, AND NOT, AS I SAID IN ERROR A MINUTE AGO, NINE
MONTHS
signed and inscribed with title
pen and ink with monochrome watercolour
8 ½ x 13 inches

180

EASY GEAR SHIFT

signed with initials

pen ink and monochrome watercolour

7 ¼ x 8 ¼ inches

181 (below)

SPRAG

signed with initials and inscribed
with title

pen ink and monochrome watercolour

8 ¾ x 7 inches

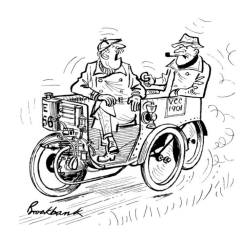

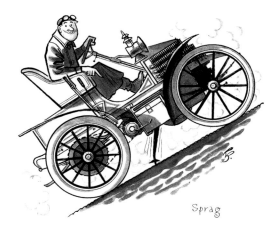

182

'AND ALL THEY DO IS
LAUGH'

1901 SUNBEAM-MABLEY
VOITURETTE

signed

inscribed with title below mount

pen and ink

5 ¼ x 4 inches

183

THE CHEQUERED FLAG

signed

pen and ink

two images each 4 x 8 inches

Illustrated: *Motor*,
20 September 1969, page 5

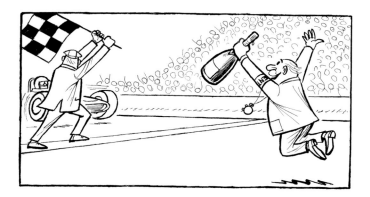

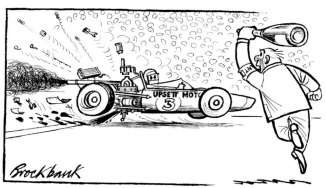

VICKY

Victor Weisz (1913-1966)

For a biography, refer to *The Illustrators*, 1997, page 183

Joined the staff of the *News Chronicle* (1939); produced his creation 'Supermac' (Harold Macmillan) in the *Evening Standard* (from 1958)

Further reading: Russell Davies and Liz Ottaway, *Vicky*, London: Secker & Warburg, 1987

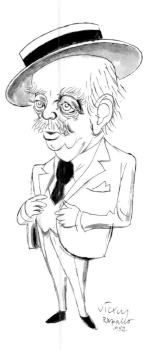

184

IN MEMORY OF MAX 1872-1956
signed, inscribed 'Rapallo' and dated 1952
pen and ink
15 ½ x 9 inches
Illustrated: *New Statesman and Nation*, 26 May 1956, page 593

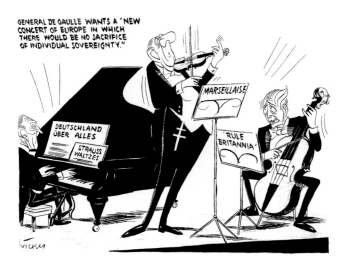

185

GENERAL DE GAULLE WANTS A 'NEW CONCERT OF EUROPE IN WHICH THERE WOULD BE NO SACRIFICE OF INDIVIDUAL SOVEREIGNTY.'
signed
pen and ink
15 x 18 inches

186

OH DEAR: EVERYTHING WAS GOING SUPER TILL RANDOLPH STARTED RUBBING THAT CONFOUNDED OLD LAMP AND WOKE UP POOR SELWYN...!
signed
pen and ink
15 x 18 inches

GILES

Carl (Ronald) Giles, OBE (1916-1995)

For a biography, refer to *The Illustrators*, 1997, pages 258-259

Contributed to the *Daily Express* and the *Sunday Express*

Further reading: Peter Tory, *Giles: A Life in Cartoons*, London: Headline, 1992

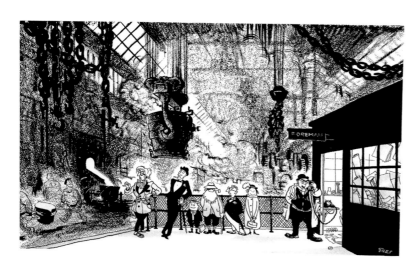

187

IS THAT THE DIRECTION OF LABOUR INTO INDUSTRY DEPARTMENT? WELL, ABOUT THESE SIX NEW HEAVY STEEL WORKERS YOU'VE SENT US...

signed
ink and watercolour
12 x 19 ½ inches
Illustrated: *Daily Express*, 17 July 1947, page 2

188

PSST! FEELTHY BANNED BMA BOOK ON GETTING MARRIED?

signed
inscribed 'to Dr Winifred de Kok with best wishes from Giles '59' on original backboard
pen and ink
12 ½ x 21 inches

In March 1959, the British Medical Association halted publication of its booklet *Getting Married*. Dr Winifred de Kok, who had edited the booklet resigned from the BMA in protest against its action. 'All we did', she said, 'was to state the facts given in the statistics. We wanted to help all young people instead of only the good ones'.

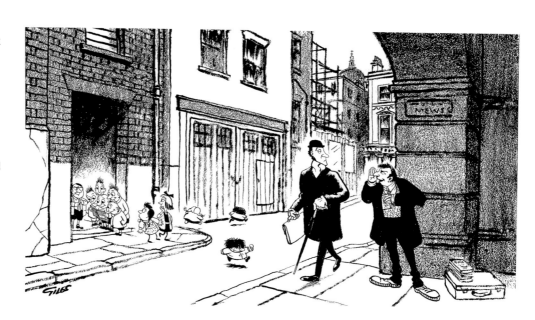

EMMWOOD

John Bertram Musgrave-Wood (1915-1999)

John Musgrave-Wood was born in Leeds, Yorkshire, on 22 February 1915, the son of a landscape painter. Educated at Leeds Modern School and Leeds College of Art, he worked in his father's studio until his death. He then served as a steward on a cruise liner and began drawing cartoons to entertain his shipmates. During the Second World War, he joined the Duke of Cornwall's Light Infantry as an instructor in physical training; he was later commissioned in the Sherwood Foresters and, while in India in 1941, volunteered to join Orde Wingate's Chindits, serving in Burma and China and attaining the rank of major. On demobilization, in 1946, he collaborated with Patrick Boyle, later Earl of Cork and Orrery, on *Jungle, Jungle, Little Chindit*, a book about his war-time experiences. He then studied painting at Goldsmiths' College, while beginning to make a reputation for himself as a cartoonist with the *Tatler*. Signing himself as 'Emmwood', he produced regular illustrations to the magazine's theatre reviews and a series of caricatures entitled 'Emmwood's Aviary'. Executing similar work for *Punch*, he moved to the *Daily Mail* in 1957, and became the newspaper's political cartoonist. He retired from the position in 1975 and moved to France, at first continuing to produce cartoons for the *Daily Telegraph*, the *Evening Standard* and other newspapers. While in France he fulfilled a long-held ambition to paint in oils. He died in Vallabrix, near Uzès, on 30 August 1999.

His work is represented in the collections of the National Portrait Gallery and the University of Kent Cartoon Centre.

Nos 189-196 are all illustrated in *Punch* for the column 'On the Air' by Henry Turton

189 (left)
THE NEW ELITE
signed
pen ink and watercolour
4 ½ x 12 ¾ inches

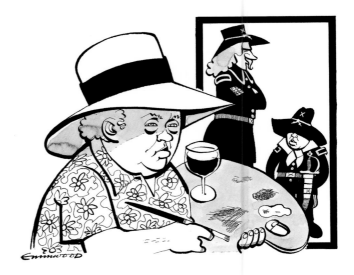

190
QUATERMASS AND THE PIT
ANDRE MORELL & CEC LINDER
signed
pen ink and watercolour
12 ½ x 7 inches
Illustrated: *Punch*, 7 January 1959, page 80, 'Quatermass Again'

191
CHARLIE DRAKE
signed
pen ink and watercolour
8 x 10 inches
Illustrated: *Punch*, 23 December 1959, page 650, 'Funny Men'

192

COMMAND IN BATTLE

FIELD-MARSHAL MONTGOMERY

signed; pen ink and watercolour

6 x 11 inches

Illustrated: *Punch*, 24 December
1958, page 848, 'The Field-Marshal'

193

TOMMY COOPER & DAVID NIXON

signed; pen ink and watercolour

12 x 7 inches

Illustrated: *Punch*, 12 November
1958, page 645, 'Abracadabra'

194

THE LARKINS

PEGGY MOUNT & DAVID KOSSOFF

signed

pen ink and watercolour

11 ½ x 7 inches

Illustrated: *Punch*, 5 November
1958, page 613, 'Back in the
Old Routine'

195 (above)

FARAWAY LOOK

PETER SCOTT

signed

pen ink and watercolour

10 x 12 ½ inches

Illustrated: *Punch*, 11
November 1959, page 446,
'Ducks and Jurymen'

196 (below)

YOU TAKE OVER

signed

pen ink and watercolour

6 ½ x 10 inches

Illustrated: *Punch*, 26
November 1958, page 710,
'Taking Over'

FRED BANBERY

Frederick Ernest Banbery (1913-1999)

For a biography, refer to *The Illustrators*, 1999, pages 211-212

Nos 197-202 are all illustrated in Michael Bond, *Paddington at the Seaside*, London: Collins, 1975, [unpaginated]

197

'I HOPE ALL THE AIR DOESN'T GET USED UP, MRS BROWN,' HE SAID IN A LOUD VOICE. AND GAVE A MAN DOING SOME DEEP-BREATHING EXERCISES A VERY HARD STARE INDEED
watercolour with pen and ink
7 ½ x 11 ½ inches
Illustrated: *Paddington at the Seaside*

198

PADDINGTON AT THE SEA-SIDE
watercolour with pen and ink
7 ¾ x 12 inches
Illustrated: *Paddington at the Seaside*, title page

199

'NO WONDER!' CRIED JUDY, AS SHE WENT TO HIS RESCUE. 'YOU HAVEN'T EVEN BOTHERED TO BLOW UP YOUR PAW-BANDS!'
watercolour with pen and ink
4 ¼ x 5 ¼ inches
Illustrated: *Paddington at the Seaside*

202

BY THE TIME HE WENT INTO THE
SEA HE WAS WEARING SO MANY
THINGS HE PROMPTLY SANK
watercolour with pen and ink
5 ¼ x 5 inches
Illustrated: *Paddington at the Seaside*

200

THE SIGHT OF THE SAND
AND WATER
watercolour with pen and ink
7 ¼ x 11 ¼ inches
Illustrated: *Paddington at the Seaside*

201

'YOU CAN HAVE A SEAT IN THE
FRONT ROW,' HE SAID TO
PADDINGTON
watercolour with pen and ink
8 x 11 ½ inches
Illustrated: *Paddington at the Seaside*

NORMAN THELWELL

Norman Thelwell (born 1923)

For a biography, refer to *The Illustrators*, 1997, page 260

Contributed to the *News Chronicle*, *Punch*, the *Sunday Dispatch*, the *Sunday Express* and the *Tatler*

Further reading: *Thelwell*, London: Chris Beetles, 1989

203

THE LONG, HOT SUMMER OF '76
signed
watercolour with crayon
7 ½ x 11 inches

204

ASK GAFFER WHAT'S BROUGHT 'IM TO THE VERGE OF RUIN THIS YEAR. THE RAIN OR THE DROUGHT?
signed and inscribed with title
pen and ink with zipatone and crayon
6 ½ x 10 inches
Illustrated: *News Chronicle*

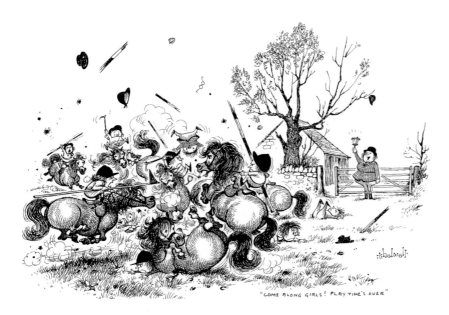

"COME ALONG GIRLS! PLAY TIME'S OVER"

205

COME ALONG GIRLS! PLAYTIME'S OVER
signed and inscribed with title
pen and ink
7 x 9 ½ inches
Illustrated: *Sunday Express*, 15 September 1963, 'Thelwell's Riding Academy'; *Penelope*, London: Eyre Methuen, 1972, page 26

FRANK HAMPSON

Frank Hampson (1918-1985)

FRANK HAMPSON AND DAN DARE

The adventures of 'Dan Dare, Pilot of the Future' were set around the year two thousand but, according to his creator Frank Hampson (1918-85), they really began in Belgium in 1944 when, as a young army lieutenant, he watched the German V-2 rockets soaring into the sky. In 1953 he wrote, 'On the quays of Antwerp you could watch the birth of Space Travel'. By that time the popularity of his strip cartoon, Dan Dare, had rocketed the sales of the *Eagle* comic into the outer stratosphere, and every week a million boys waited with bated breath for the next episode.

The son of a policeman, Frank Hampson was born in a small terraced house in Audenshaw, near Manchester, on 21 December 1918. Three months later he moved with his family to Southport, and it was there that he spent his early life. Revealing a talent for drawing while a pupil at George V Grammar School, he attended life classes at the local school of art when he began to work for the Post Office. Then, in 1938, at the age of nineteen, he became a full-time art student at the Victoria College of Arts and Science. The following year, he gained an intermediate National Diploma of Design but, with the outbreak of the Second World War, volunteered for the army, in which he rose to the rank of lieutenant. During the next six years he saw action in France and Belgium, and lived through the experiences that would inform and influence much of his future creativity. Following his discharge, he spent three years at Southport School of Arts and Crafts; Harold Johns and Eric Eden, who both later joined his studio, were among his contemporaries.

As Hampson was married with a son, he had to find freelance work to supplement his grant. He provided illustrations to *Anvil*, a Church of England magazine which had been turned from a 'Parish Mag' into a national publication through the entrepreneurial talents of a local parson, the Reverend Marcus Morris. But Morris had his eye on wider horizons. He wanted to produce a comic strip for boys that would combat the influx of American horror comics with their crude and senseless violence, and promote Christian values. Initially, he asked Hampson to draw a single strip about an East End vicar 'Lex Christian'. This completely failed to get off the ground

but, stirred on by defeat, they decided to go all out and produce an entire comic instead.

Hampson suggested that outer space and science fiction would provide a wider and more enticing playing field than the East End of London, and he transformed Lex Christian into 'Chaplain Dan Dare of the Interplanet Patrol', complete with dog-collar and cape. Finally, he decided to drop the overt Christian message entirely and call him simply, Colonel Dan Dare. And so Dan Dare – the front page strip 'that sold the *Eagle*' – was born. His religious origins may now be hidden – but they were still undeniably there; Dan was named after Hampson's mother's favourite hymn, *Dare to be a Daniel*, and the comic's title, *Eagle*, inspired by a large eagle-shaped lectern which Hampson's wife, Dorothy, had mused upon in church.

210 (detail)

With Hampson's superbly drawn, brightly coloured dummy in his hands – full to the brim with imaginative adventures – Morris now had something to show potential publishers, and he began the long slog up and down Fleet Street. Then, in September 1949, he received a telegram from Hulton Press, publishers of *Picture Post*, which read 'Definitely interested – do not approach any other publisher.' And so, early in 1950, contracts were signed – and copyrights were forfeited. But this was a birth, and for now at least, a cause for celebration. A studio was set up in a ramshackle old bakery in Churchtown, near Southport, and Hampson set about assembling a team of artists: Joan Porter, Greta Tomlinson, Harold Johns, Jocelyn Thomas and Bruce Cornwall. (At various times Eric Eden, Max

Dunlop, Don Harley, Keith Watson and Gerry Palmer would also work for the studio.)

Hampson's father, now retired from the police force, became a willing general helper, as well as the very recognisable model for the Controller of the Space-Fleet, Sir Hubert Guest. Indeed, the characters in the strip, often based on real people, were completely believable human beings, and family members and studio artists alike were expected to model for the drawings and pose for photographs, in order to ensure the accuracy of each frame. Similarly, the futuristic technology was thoroughly thought out and designed to look as though it would work. Intense research, model making, and a vast reference library, were all employed to this end.

At this stage, Hampson not only carried overall responsibility for all the art work on *Eagle*, drew 'Dan Dare', 'Great Adventurer', and various other strips and pages; he also wrote the stories. Many Dan Dare fans believe that the multi-dimensional magic of early Dan Dare stories, *The Venus Story* and *The Red Moon Story*, communicated as powerfully at a written level as they did at a richly visual one; and that this quality was lost to some degree when, through sheer pressure of work, Hampson was finally forced to stop writing all his own material.

Eagle flourished, and the first print run sold every one of its 900,000 copies. Unsurprising perhaps – because Britain had never seen anything like this before. In a decade of technological pessimism (the bomb, the cold war, etcetera), here was a comic with stories that were optimistic, intensely colourful and richly detailed, both visually and in their story line. And with the possibility of space travel fast becoming a reality, they contained the irresistible combination of realistic contemporary heroes fighting evil and tyranny in an exciting, imaginative and entirely believable parallel world.

208 (detail)

Before long it became clear that larger premises were essential, and it was decided to move the whole studio closer to Hultons in London. And so, early in 1950, the Morrises, the Hampsons (including Frank's parents) and the entire studio team, moved south to Epsom, in Surrey. However, in 1959, things began to go wrong, Hultons having been taken over by Odhams, a rival publisher. While recognising the success of Dan Dare as vital to *Eagle*, the executives at Odhams did not understand that such high quality work could only be maintained through the working system evolved by Hampson and his team. They viewed this as hugely expensive and wasteful and, amidst great personal turmoil for Hampson, the studio was disbanded. The golden age of Dan Dare was at an end and, powerless without a copyright, Hampson could only disassociate himself from the changes, which he knew would lead to the diminution of his creation.

206 (detail)

For many years, the very name Dan Dare remained anathema to Frank Hampson, never to be mentioned in his presence. But the space hero had an international band of followers dedicated to his creator. Attempts to contact him were usually firmly ignored, but then, unaccountably, towards the end of 1973 he began, just occasionally, to respond. In 1975, he was invited by Denis Gifford to attend the major biennial awards festival in Lucca, Italy, the 'Mecca' for devotees of strip cartoons. With some misgivings, he decided to go, taking a selection of the original artwork with him. He had no expectation of anything special, and so was amazed when, on his arrival, he was feted and presented with the Yellow Kid Award, the only English artist to have achieved this; and was honoured with a further award, which had been created

especially for him, acknowledging him as 'Prestigioso Maestro', 'The best writer and illustrator of strip cartoons since the end of World War Two'. The Ally Sloper Award soon followed and, suddenly, Dan Dare was big news again. Reprints of the stories were produced, articles appeared in the national press, Eagle comic was relaunched (if briefly), and there were interviews on television.

Hampson died in 1985 but, as he had predicted, Dan Dare lived on. The character that influenced a whole generation of boys had entered the English language and been recognised, in the words of Terry Jones, as 'One of the great creations of Twentieth Century imaginative literature'. The reason for this is not difficult to find. Look at the best of the strips of the 1950s, and you will see technology that still appears fresh, futuristic and workable. Look at the trouble taken to draw the reflections on the surface of a helmet, and you will get some idea of the care and dedication that went into a product that respected its readers, and was determined to give them the best. Look at the vision of a world united as a force for good under the United Nations and see the post-war optimism that typified the decade, and still has huge resonance and relevance today. There is no doubt that Hampson was a genius of the genre. As Professor Wolf Mankovitz said of him, 'Frank is, without doubt, the creator of a new 21st Century mythology – a great artist in his extraordinary medium.'

P and S Hampson

208 (detail)

Frank Hampson in his studio late 1970s

Meeting the readers. Frank Hampson with his son Peter in his arms, at Radio Luxembourg circa 1951

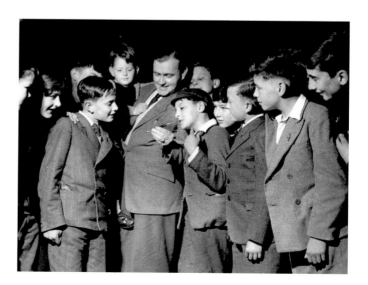

THE VENUS STORY

The Venus Story was the first Dan Dare story to appear in *Eagle*, running for approximately seventeen months. The boards included here were published a couple of months after the launch of the comic on 14 April 1950.

The year is 1996. Earth is no longer able to feed its population. The World Government has sent missions to Venus to explore the possibility of food production there, but the spaceships are being destroyed before they reach their destination. Dan Dare, crack pilot of the Interplanetary Space Fleet is sent to investigate. With him he takes his batman (Digby), two other space pilots (Hank Hogan and Pierre Lafeyette), the Controller of the Space Fleet (Sir Hubert Guest) and a female scientist (Jocelyn Peabody). Their mother ship is also destroyed on the outskirts of Venus, but they escape in smaller rocket ships and crash land on the planet. They eventually encounter the war-like inhabitants of the planet – the Treens. In a fight, Dan is accidentally hit by a paralysing ray, falls into a river and is swept away. All his companions are captured. Dan is carried for miles along the underground river, and eventually emerges into a part of the planet populated by the Therons. These are a peaceable race, divided from the Treens after years of conflict by the 'flame-belt' which encircles the planet. Dan returns, via a subterranean river and disguised by the Therons as an Atlantine (a race of people captured and enslaved aeons before by a Treen raiding party to earth) to rescue his companions. He comes across an Atlantine village, but is discovered as a stranger and accused of being a Treen spy. He is cornered, but the Atlantines realise that his physical characteristics are similar to those of the legendary Kargaz, who they believe will one day release them from Treen tyranny. Dan is infiltrated into the Treen controlled Atlantine army, where he sparks a rebellion and rescues his companions. He captures the leader and evil mastermind of the Treen race, the diminutive but vast-headed Mekon. Dan and his companions eventually escape and defeat the Treen army, but the Mekon – the implacable enemy of Dan Dare – lives to fight another day.

P and S Hampson

Nos 206-212 are all from the Estate of Frank Hampson

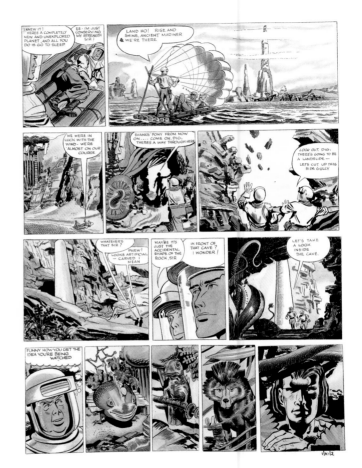

206

I KNEW IT! HERE'S A COMPLETELY NEW AND UNEXPLORED PLANET, AND ALL YOU DO IS GO TO SLEEP

pen ink and watercolour

20 ¼ x 14 ¼ inches

Illustrated: *Eagle*, volume 1, issue 10, page 2, 'Dan Dare'

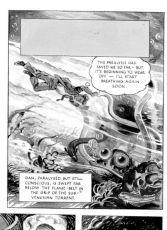

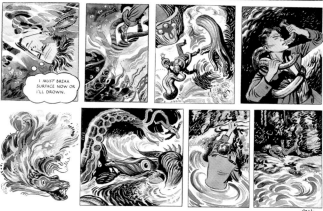

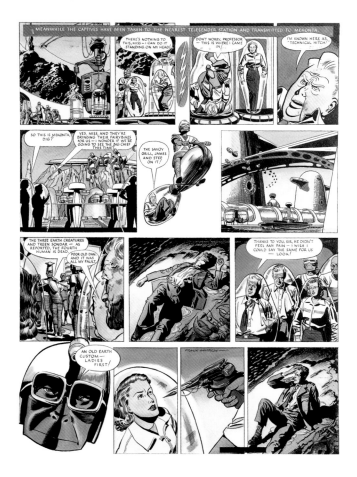

207

DAN, PARALYSED BUT STILL CONSCIOUS, IS SWEPT FAR BELOW THE
FLAME-BELT IN THE GRIP OF THE SUB-VENUSIAN TORRENT
pen ink and watercolour
19 x 14 ½ inches
Illustrated: *Eagle*, volume 1, issue 28, page 1, 'Dan Dare'

208

MEANWHILE THE CAPTIVES HAVE BEEN TAKEN TO THE NEAREST
TELESENDER STATION AND TRANSMITTED TO MEKONTA
pen ink and watercolour
20 x 14 ½ inches
Illustrated: *Eagle*, volume 1, issue 28, page 2, 'Dan Dare'

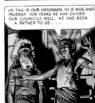
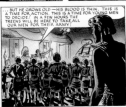
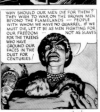

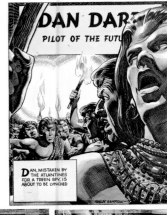
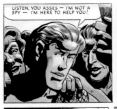
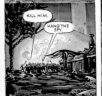
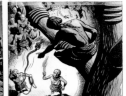
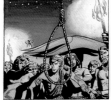

209

DAN, DISGUISED AS AN ATLANTINE, APPROACHES AN ATLANTINE VILLAGE

pen ink and watercolour

19 ¼ x 14 ½ inches

Illustrated: *Eagle*, volume 1, issue 45, page 1, 'Dan Dare'

210

DAN DARE; PILOT OF THE FUTURE

DAN, MISTAKEN BY THE ATLANTINES FOR A TREEN SPY, IS ABOUT TO
BE LYNCHED

pen ink and watercolour

19 x 14 ½ inches

Illustrated: *Eagle*, volume 1, issue 46, page 1, 'Dan Dare'

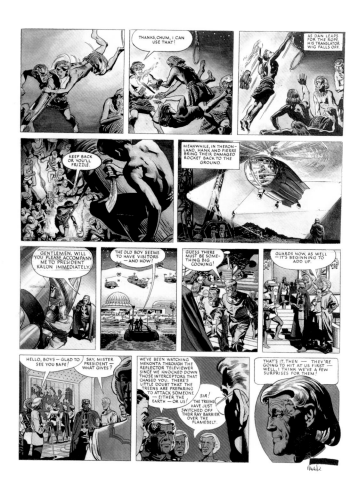

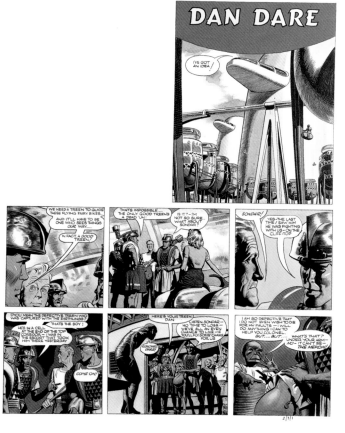

211

THANKS, CHUM, I CAN USE THAT!

pen ink and watercolour

19 x 14 ½ inches

Illustrated: *Eagle*, volume 1, issue 46, page 2, 'Dan Dare'

212

DAN DARE

I'VE GOT AN IDEA!

pen ink and watercolour

19 x 14 ½ inches

Illustrated: *Eagle*, volume 2, issue 3, page 1, 'Dan Dare'

RONALD SEARLE

Ronald William Fordham Searle, AGI NS (born 1920)

For a biography, refer to *The Illustrators*, 1999, pages 227-228; for essays on various aspects of the artist's achievement, refer to *The Illustrators*, 1999, pages 228-230; and *The Illustrators*, 2000, pages 40-42

Key works illustrated: Contributed to *Punch* (from 1946); *Hurrah for St Trinian's* (1948); Geoffrey Willans, *Down with Skool!* (1953)

His work is represented in numerous public collections, including the British Museum, the Imperial War Museum, the Victoria and Albert Museum and the Bibliothèque Nationale (Paris).

Further reading: Russell Davies, *Ronald Searle*, London: Sinclair Stevenson, 1990

213

TWELVE DAYS OF CHRISTMAS — AND A PARTRIDGE IN A PEAR TREE...
signed and dated 1982
inscribed with title and dated 1982
on reverse
watercolour, pen ink and crayon
12 x 9 inches
Design for a Christmas card for Camden Graphics, London, 1982

214

THE GOURMAND
signed, inscribed with title and dated 1995
pen ink and watercolour
18 x 16 ½ inches
Illustrated: *Yankee Magazine*, Summer 1995

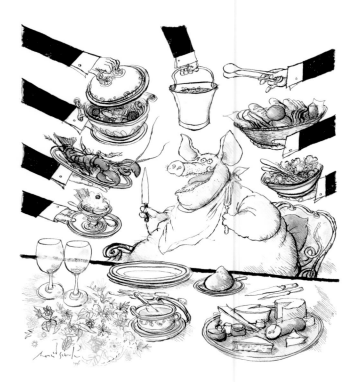

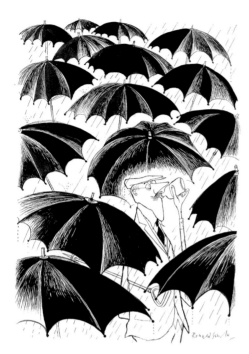

215

HAVE A GOOD RUM FOR YOUR MONEY II
signed and inscribed with title
pen and ink
15 x 10 inches
Design for Lemon Hart Rum
advertisement, 1950s

216

WINESPEAK
KNIT TO A HARMONIOUS WHOLE
signed, inscribed with title and dated 1983
pen ink and watercolour
12 ¾ x 9 inches
Illustrated: *Winespeak, the Wicked World of*
Winetasting, London: Souvenir Press, 1983,
page 47

217

HAVE A GOOD RUM FOR YOUR
MONEY III: TWO IN HARMONY
signed
pen and ink with watercolour and
bodycolour
18 x 16 inches
Design for Lemon Hart Rum
advertisement, 1950s

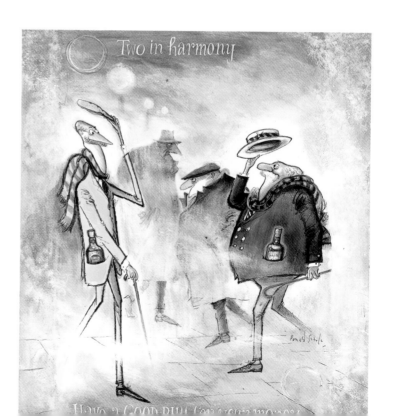

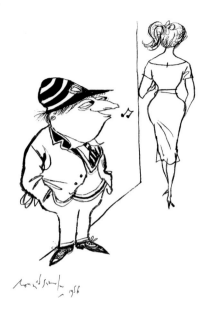

218

DERE LITTLE CHAPS. PARKINS SHOWS A
GREAT DEAL OF PROMISE
signed, inscribed with title, 'Whizz for
Atomms' and dated 1956
pen and ink
9 ½ x 7 inches
Illustrated: *Whizz for Atomms*, page 82;
Molesworth, page 286

219

EVERY SKOOL HAV A RESIDENT BULY
WHO IS FAT
signed, inscribed with title and dated 1954
pen and ink
10 x 8 inches
Illustrated: Geoffrey Willians and
Ronald Searle, *How to be Topp*, London:
Max Parrish, 1954, page 49;
Molesworth, page 149

220

MOLESWORTH 2 ZOOM DOWN WITH
HIS ROTORS WHIRRING...
signed, inscribed with title, 'Whizz for
Atomms (page 22)' and dated 1956
pen and ink
9 ½ x 9 ½ inches
Illustrated: *Whizz for Atomms*, page 22;
Molesworth, page 227

221

MOLESWORTH: AN ACT OF CHARITEE
signed, inscribed with title and dated 1956
pen and ink
14 ¾ x 10 inches
Illustrated: *Whizz for Atomms*, page 17;
Molesworth, page 221

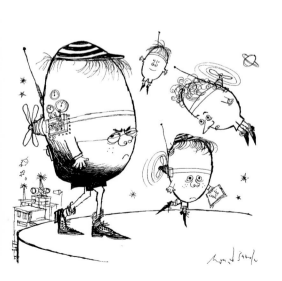

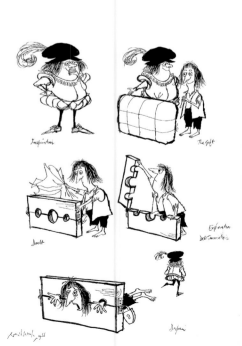

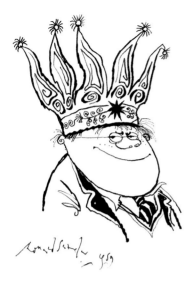

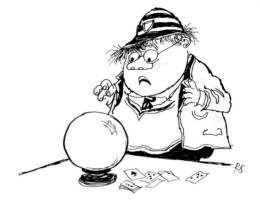

223 (below)

MOLESWORTH

signed with initials

pen and ink

4 ½ x 4 ½ inches

Illustrated: Geoffrey Willans and Ronald Searle, *Back in the Jug Agane*, London: Max Parrish, 1959, page 25;

Geoffrey Willans and Ronald Searle, *The Compleat Molesworth*, page 327;

Molesworth, page 331

224 (above)

NIGEL MOLESWORTH

GO GOSH CRIKEY — LORD MARE OF LONDON

signed, inscribed with title and dated 1959

pen and ink with coloured pencil

7 ¾ x 7 inches

222

MOLESWORTH: COO, GOSH, CHRISTMASS

signed, inscribed with title and dated 1959

pen and ink

7 ¾ x 6 inches

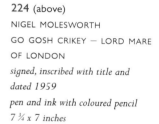

Nos 218, 220-221 are illustrated in Geoffrey Willans and Ronald Searle, *Whizz for Atomms*, London: Max Parrish, 1956

Nos 218-221, 223 are illustrated in Philip Hensher (introduction), Geoffrey Willans and Ronald Searle, *Molesworth*, London: Penguin Twentieth-Century Classics, 1999

225

MOLESWORTH FOOTBALLER

signed, inscribed 'Molesworth: Back in the Jug Agane' and dated 1959

pen and ink

8 x 8 ¼ inches

Drawn for but not illustrated in *Back in the Jug Agane*

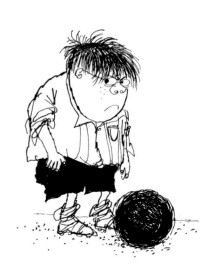

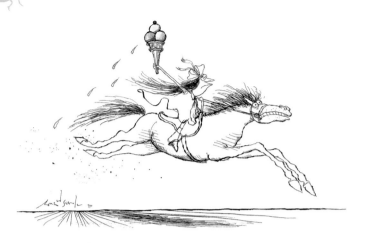

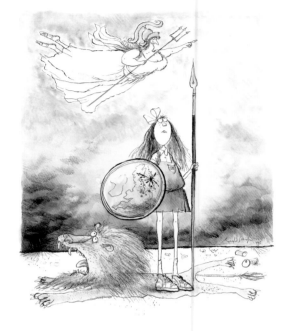

226

ST T'S RIDES AGAIN

signed, inscribed with title and dated
1994; pen ink, watercolour and
coloured crayon
10 x 15 inches
Illustrated: *New York Times*, 16 March
1994, page A21, 'No E-Mail from
Walden' by Bill Henderson

227

THE FOOD OF LOVE

signed, inscribed with title and
dated 1957
pen ink and bodycolour
8 x 9 inches
Design for an ashtray by Nymolle
Ceramics, Copenhagen

228

MEMORIES OF THINGS PAST

signed, inscribed with title and dated 1996
pen ink and watercolour; 20 x 16 inches
Illustrated: *Sunday Times Magazine*, 21 July 1996, page 19,
'Britain. the state we're really in'

229

SEARLE'S-EYE VIEW

17 — IRIS MURDOCH AS THE

IMAGINATION SEES HER

signed, inscribed 'Imaginary Portraits —
Iris Murdoch' and dated '21 March
1962'
pen and ink
16 x 16 inches
Illustrated: *Punch*, 21 March 1962,
page 478

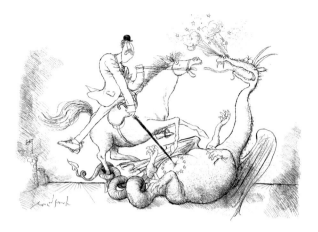

230

L'EUROSCEPTIQUE

signed and inscribed with title

inscribed 'St George and the Euro Dragon' and dated 1997 on reverse

pen and ink; 16 ½ x 19 ¾ inches

Illustrated: *Le Monde*, Paris, 26 March 1997, page 17

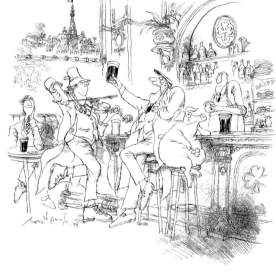

231

PARIS FOLKLORE

IRISH PUBS ALL OVER

signed, inscribed with title and dated 1997

pen and ink

17 x 16 inches

Illustrated: *International Herald Tribune*, Paris, 15-16 March 1997, page 24, 'Green Power: the Irish Pub Invasion' by Mary Blume

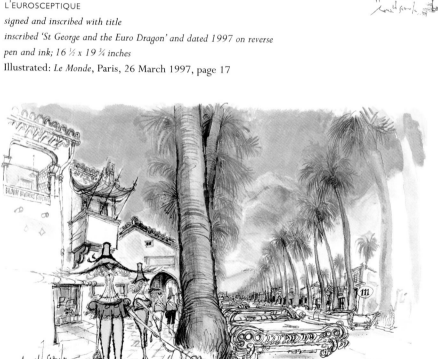

232

WALKIES: PALM SPRINGS

signed and inscribed 'Palm Springs' and dated 1963

watercolour, pen ink and bodycolour

15 x 20 inches

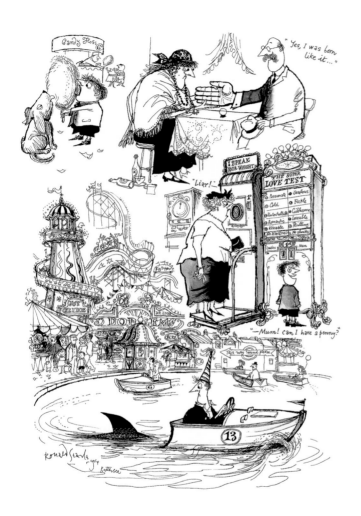

233
MIDSUMMER EVE'S DREAM. BATTERSEA FUNFAIR IS IN FULL SWING
signed, inscribed 'Battersea Fun Fair' and dated 1954
pen and ink
21 x 14 ¾ inches
Illustrated: *News Chronicle*, 19 June 1954, page 4
Ronald Searle, *Merry England*, London: Perpetua Books, 1956, pages 64-65

234
SPARE A COPPER...
signed, inscribed 'News Chronicle. Street Scenes' and dated 1954
pen and ink
22 x 14 ¾ inches
Illustrated: *News Chronicle*, 19 September 1954, page 4
Ronald Searle, *Merry England*, London: Perpetua Books, 1956, pages 3,7 and 82

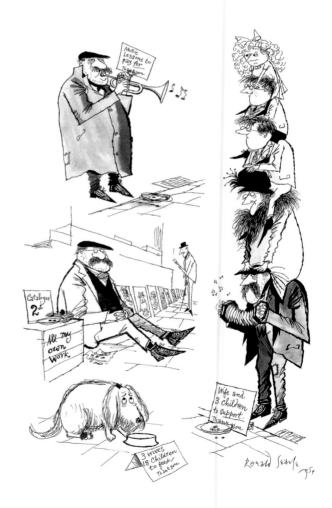

JOHN BURNINGHAM

John Mackintosh Burningham (born 1936)

For a biography, refer to *The Illustrators*, 1993, page 166

235

GRANDPARENTS

pen and ink

4 ¾ x 7 ½ inches

Illustrated: *The Time of Your Life*,
page 134

Nos 235-237 are illustrated in
John Burningham, *The Time of
Your Life*, London: Bloomsbury,
2002

236 (above right)

IF YOU LIVE TO NINETY IN
ENGLAND AND CAN STILL EAT A
BOILED EGG THEY THINK YOU
DESERVE THE NOBEL PRIZE

pen and ink with pencil

9 ¼ x 9 ¼ inches

Illustrated: *The Time of Your Life*,
page 52

237

DANCING ON THE SAND

*pastel with pen, ink, bodycolour, pencil
and collage*

14 x 24 inches

Preliminary drawing for *The Time of
Your Life*, front cover

EDWARD MCLACHLAN

Edward Rolland McLachlan (born 1940)

Ed McLachlan's cartoons offer a comical but often cutting commentary on modern life. From his gormless baggy-suited businessmen to his ungainly bucktoothed women, his undeniably British sense of humour makes him a master of the macabre with an eye for the ridiculous. In every cleverly observed image, he takes the mundane and delivers the hilariously absurd.

With bold and simple lines, McLachlan takes his inspiration from famed twentieth century illustrators such as Andre François, Giles, Leo Baxendale and Saul Steinberg; but the flamboyance and animation of his characters is peculiarly his own. With captions or without, his work often teeters on the edge of political correctness and with every cartoon offers us a fresh glimpse into the comedic genius of McLachlan's world.

Born on 22 April 1940 in Humberstone, Leicestershire to Scottish-Irish parents, McLachlan grew up in a household where reading comics was actively discouraged. Even his schooling – at Humberstone Village School and Wyggeston Grammar – did little to nurture his artistic flair. It wasn't until he went to Leicester College of Art that his talent finally found expression. He graduated with honours in 1959 at the unusually young age of 18 and returned to his alma mater in 1967-70 to lecture in Graphics. He financed his studies doing weekend work as a builder's labourer – such labourers would later come to life in his pen and ink creations.

McLachlan got his first break on *Punch* in 1961, working for a

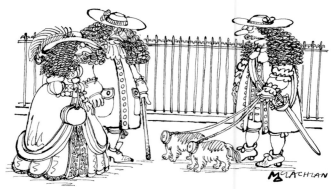

"Actually, they're King Charles the First spaniels"

238
SUNFLOWERS?
signed
pen ink and watercolour
15 x 11 ¾ inches

239
ACTUALLY, THEY'RE KING CHARLES THE FIRST SPANIELS
signed and inscribed with title
pen and ink; 8 ½ x 14 inches

meagre five pounds a week. After five years he went freelance. During a prolific career spanning over four decades his work has appeared in magazines such as *Private Eye*, the *Spectator*, *New Statesman*, *Investor's Chronicle* and of course *Punch*. His newspaper contributions include the *Sunday Mirror*, *Daily Mirror*, *Mail on Sunday* and *Sunday Telegraph*.

McLachlan has also turned his talents to the screen where he has designed and written more than 300 commercial advertising films. He was voted Illustrative Cartoonist of the Year 1980, CCGB Advertising Cartoonist of the year in 1981 and CAT Gag Cartoonist of the Year 1997.

A favourite pursuit continues to be writing and drawing children's books and he has already illustrated over 200 including P Groves, *Banger and Mash* series (40 books from 1975) and R Kilroy, *Graffitti* series (1979-81). In addition he wrote and designed the ITV series, *Simon and the Land of Chalk Drawings* and designed *Bangers and Mash* for the same company.

Away from the easel, McLachlan spends him time weight-training, cycling and supporting Leicester Tigers Rugby Club.

Helena Murray

"This new king of ours, this George the First, he's very German, isn't he?"

240

THIS NEW KING OF OURS, THIS GEORGE
THE FIRST, HE'S VERY GERMAN, ISN'T HE?
signed and inscribed with title
pen and ink; 11 x 9 ½ inches
Illustrated: *Spectator*

241
INDEPENDENCE DAY
signed
pen ink and watercolour
20 x 15 ¾ inches
Illustrated: *Punch*, 2 July 1986,
front cover

242
DAD — THE COMPUTER WAS
RIGHT. IT IS SPRING!
signed
pen ink and watercolour
15 x 12 inches

243
HOW TO INCORPORATE
THE ARMS
signed
pen and ink
15 ½ x 11 inches
Illustrated: *McLachlan*, London:
Methuen, 2001, page 20

"I know Jack Russell Terriers are plucky little dogs and utterly fearless but....."

244
I KNOW JACK RUSSELL TERRIORS ARE PLUCKY
LITTLE DOGS AND UTTERLY FEARLESS BUT...
signed and inscribed with title; pen and ink
12 ¾ x 9 ½ inches
Illustrated: *Spectator*

WHILST DOING A LONG OVERDUE CLEAROUT
AT THE OFFICES OF IRELAND'S OLDEST AND
MOST RESPECTED SCHOOL OF DANCE, MRS O'HARA
MADE A TERRIBLE DISCOVERY.......

JONATHAN WATERIDGE

Jonathan Wateridge (born 1972)

Jonathan Wateridge was born in Lusaka, Zambia on 21 March 1972. As the son of a newspaper publisher, he had access to many weekly periodicals, and so grew up with a knowledge of a full range of cartoonists 'from John Jensen to McLachlan, ffolkes to Trog, Larry to David Levine'. From the age of eight he was determined to become a cartoonist, and developed a comic strip, drafts of which he would send to various English newspapers, though with little success.

Moving to England to attend school, his interest in fine art was fired, from the age of fourteen, by 'a hugely gifted painting teacher', and he spent much of the following four years drawing and painting from life. This experience enabled him to go straight into the second year at Glasgow School of Art, an institution with a strong tradition of figurative painting. However, he soon turned to 'more conceptual and contemporary ways of making pictures', and has gradually established himself as an artist in film, video and multi-media.

While developing a new body of work during the mid 1990s, Wateridge took up illustration as a way of supplementing his income. He began by making the occasional contribution to *Time* magazine, its new art editor having bought some of his teenage work years earlier. Armed with these commissions, he contacted other periodicals. Fortuitously, Frank Johnson – then editor of the *Spectator* – said that he was looking for an artist to produce covers, as a successor to Peter Brookes, who was increasingly committed to *The Times*. This led, in turn, to regular work with *The Times Literary Supplement*. He has since produced illustrations, and particularly covers, for the *Economist*, *The Sunday Times Magazine*, the *Daily Telegraph*, the *Evening Standard*'s *Hot Tickets* magazine, *Sette* magazine (Italy), *Literaturen* (Germany). He is exhibiting his illustrations for the first time.

245

SIR JOHN GIELGUD
signed; pen and ink
15 ½ x 15 ½ inches
Illustrated: *The Times Literary Supplement*, 9 December 2000, front cover

246

BUSINESS AS USUAL
signed; watercolour and bodycolour
11 ¾ x 14 ½ inches
Illustrated: *Spectator*, 6 October 2001, page 36

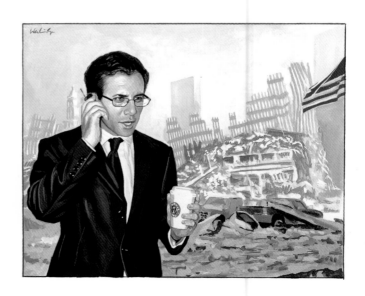

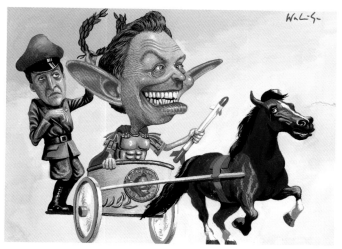

247

VICTORUM EMPEROR TONY

signed; watercolour and bodycolour; 12 ¼ x 16 ¾ inches

Illustrated: *Spectator*, 12 June 1999, front cover and page 12, 'Was it really worth it?' by Alistair Horne [on the war in the Balkans]

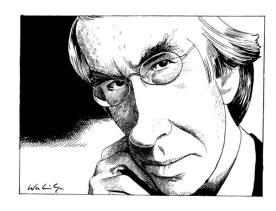

249

FEEDING THE RUSSIAN BEAR

signed; watercolour and bodycolour
12 ½ x 16 inches

Illustrated: *Spectator*, 5 September 1998, front cover, pages 5 and 11, 'Russia, land of enterprise' by Norman Lamont

250

IAN MCEWAN

signed
pen and ink
8 x 10 ¼ inches

Illustrated: *The Times Literary Supplement*, 28 September 2001, front cover

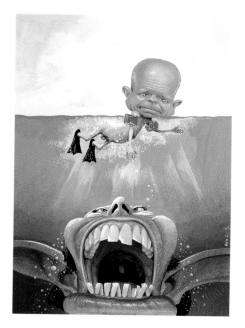

248

JAWS
signed
watercolour and
bodycolour
17 x 12 inches

Illustrated: *Spectator*,
12 May 2001, front
cover and page 10,
'Stand up for the
forces of
Conservatism' by
Matthew Parris

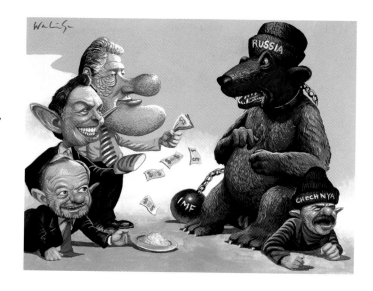

MIKE WILLIAMS

Michael Charles Williams (born 1940)

For a biography, refer to *The Illustrators*, 1999, page 245

251

GOTT IN HIMMEL! SOMEBODY
MUST HAVE A FRANC!!
signed and inscribed with title
pen and ink with watercolour
8 ¾ x 11 ½ inches

SIMON DREW

Simon Brooksby Drew (born 1952)

For a biography, refer to
The Illustrators, 1997, page 263

Key work written and illustrated: *A Book of
Bestial Nonsense* (1986)

252

WE ARE NOT A MOOSE
inscribed with title
pen ink and coloured crayon
8 x 5 inches
Design for a greetings card

253

THE JOY OF SETS
inscribed with title
pen ink and coloured crayon
8 x 5 ½ inches
Design for a greetings card

"We are not a moose."

the joy of sets

NICK BUTTERWORTH

Nicholas Butterworth (born 1946)

Nick Butterworth was born in Kingsbury, North London, but moved to Romford, Essex, at the age of three when his parents took over a confectionery and newsagent. The shop gave him unlimited access to a wide range of inspiring comics, and from an early age he filled sketchbooks with cartoons. This talent for drawing was encouraged by his art teacher. Then, on leaving school, he trained as a typographic designer in the printing department of the National Children's Home. After working for several major design consultancies, including Pentagram, he formed a graphics partnership with other artists, including Mick Inkpen. Illustration proved such an important element of his work that, in 1980, he decided to concentrate on books for children. The reactions of his own son and daughter helped him to hone his texts and images to robust youthful tastes. On completing his first book, *B B Blacksheep & Company*, he began to produce the 'Upney Junction' strip for the *Sunday Express Magazine*. The success of the strip led to live appearances on the new TV-AM, telling and illustrating stories on Sunday mornings. Most of the stories were written by Mick Inkpen, who then developed as his regular partner in work on books, greetings cards and television programmes. Some of the illustrations for these projects were produced collaboratively, Butterworth drawing the line and Inkpen adding colour. However, Butterworth now tends to work alone. He is probably best known for the series featuring Percy the Park Keeper, which began in 1989 with *One Snowy Night*, while another of his acclaimed books, *QPootle5*, is likely to be animated for children's television. Though he dislikes children's books that moralise, he hopes that his work conveys the values of friendship and kindness. He also believes that good design is essential to the success of a book, and has stated:

> To open the cover of such a book is like opening a doorway into a world of imagination where the things that happen have the effect of sending the reader back to the real world with a new sense of possibilities.

254

TIME OUT

watercolour and ink

6 ¾ x 5 inches

Design for a greetings card for Gordon Fraser

255

'SURELY NOT', THOUGHT PERCY.
BUT THE FOX'S NEW FRIEND DID
LOOK VERY PLEASED WITH HIMSELF
signed and inscribed with title
watercolour and ink
8 ½ x 15 ½ inches
Drawn for but not illustrated in
the 'Percy the Park Keeper' series
(published from 1989)

256

CAROL MICE
watercolour and ink
7 ¼ x 5 inches
Design for a greetings card for
Gordon Fraser

"Surely not," thought Percy. But the Fox's new friend did look very pleased with himself. NickButterworth

PETER CROSS

Peter Cross (born 1951)

For a biography, refer to *The Illustrators*, 1997, page 277

Key works written and illustrated: *1588 and all this...* (1988); *The Boys' Own Battle of Britain* (1990)

Gallery favourite, Peter Cross has a long-established reputation as a book illustrator. In recent years, he has worked with even greater success in other areas of illustration, particularly on advertising for Wine Rack and on designs for greetings cards. Introduced to card design by Andrew Brownsword, a guru in the field, he developed 'Harbottle & Co' during the mid 1990s for Gordon Fraser. Following the takeover of Gordon Fraser by Hallmark, at the close of the decade, he created Parky the Penguin, and has since evolved his appearance into a definitively cute form.

Nos 257-268 are designs for greetings cards

257
CHRISTMAS EVE
signed with initials
watercolour with pen and ink
7 ¼ x 5 ¼ inches

258
MOTTLED STILTON
signed with initials
watercolour with pen and ink
5 ½ x 4 ¾ inches

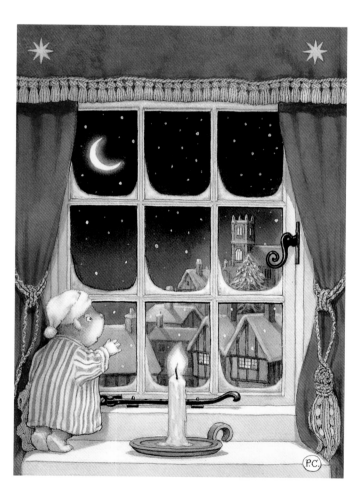

260

SUPER STAR !

signed with initials and inscribed
with title
watercolour with pen and ink
4 ½ x 5 ¼ inches

261

JUMPING FOR JOY
signed with initials
watercolour with pen and ink
3 x 2 inches

259

GOAL !
signed with initials
watercolour with pen and ink
5 ½ x 5 inches

N

PARKY'S
Peng Shui

W E

The ancient oriental art
of
PENGUIN ARRANGING

S

Parky's Fishing.com

Using the net !

262

USING THE NET
signed with initials
watercolour with pen and ink
6 ½ x 6 ¼ inches

263

PENG SHUI
signed with initials
watercolour with pen and ink
6 x 6 inches

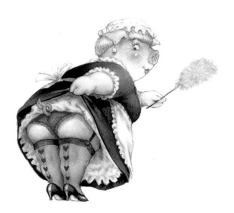

264

TICKLED PINK
signed with initials
watercolour with pen and ink
5 x 5 inches

265

FOR MY VALENTINE...
signed with initials
watercolour with pen and ink
5 ¼ x 3 ¼ inches

Celebrate with a bottle...

266

CELEBRATE WITH A
BOTTLE
signed with initials
watercolour with pen
and ink
4 ½ x 5 ½ inches

Oceans of Love

267

OCEANS OF LOVE
signed with initials
watercolour with pen and ink
4 ¼ x 4 ¾ inches

268

CHECKING THE CHRISTMAS POST
signed with initials
watercolour with pen and ink
9 ¼ x 7 inches

SELECT BIBLIOGRAPHY

Allgemeines Künstler-Lexicon, Munich/Leipzig: K G Saur, from 1992

E Benézit, *Dictionnaire critique et documentaire des peintres, sculpteurs, dessinateurs et graveurs*, Paris: Librarie Grund, 1976 (10 volumes)

Mark Bryant, *Dictionary of Twentieth-Century British Cartoonists and Caricaturists*, Aldershot: Ashgate Publishing, 2000

Mark Bryant and Simon Heneage, *Dictionary of British Cartoonists and Caricaturists 1730-1980*, Aldershot: Scolar Press, 1994

Humphrey Carpenter and Mari Prichard, *The Oxford Companion to Children's Literature*, Oxford University Press, 1984

John Christian (editor), *The Last Romantics: The Romantic Tradition in British Art*, London: Lund Humphries/ Barbican Art Gallery, 1989

Alan Clark, *Dictionary of British Comic Artists, Writers and Editors*, London: The British Library, 1998

David Cuppleditch, *The London Sketch Club*, Stroud: Alan Sutton Publishing, 1994

Dictionary of National Biography, various publishers, from 1885

William Feaver, *Masters of Caricature. From Hogarth and Gillray to Scarfe and Levine*, London: Weidenfeld and Nicolson, 1981

Denis Gifford, *The British Comic Catalogue 1874-1974*, London: Mansell, 1975

Richard Godfrey (introduction), *English Caricature. 1620 to the Present*, London: Victoria and Albert Museum, 1984

Edward Hodnett, *Five Centuries of English Book Illustration*, Aldershot: Scolar Press, 1988

Alan Horne, *The Dictionary of 20th Century Book Illustrators*, London: Antique Collectors' Club, 1994

Simon Houfe, *The Dictionary of British Book Illustrators 1880-1914*, Woodbridge: Antique Collectors' Club, 1981; 1996 (revised editions)

Simon Houfe, *Fin de Siècle: The Illustrators of the 'Nineties*, London: Barrie & Jenkins, 1992

Robin Jacques, *Illustrators at Work*, London: Studio Books, 1963

Diana L Johnson, *Fantastic Illustration and Design in Britain 1850-1930*, Providence: Rhode Island School of Design, 1979

John Lewis, *The 20th Century Book*, London: Herbert Press, 1967

David Low, *British Cartoonists, Caricaturists and Comic Artists*, London: William Collins, 1942

Edward Lucie-Smith, *The Art of Caricature*, London: Orbis Publishing, 1981

Janet McKenzie and Michael Spens, *High Art and Low Life: 'The Studio' and the 'fin de siècle'*, Washington: The Arthur M Sackler Foundation, 1993

Douglas Martin, *The Telling Line. Essays on fifteen contemporary book illustrators*, London: Julia MacRae Books, 1989

Jane Martineau (editor), *Victorian Fairy Painting*, London: Royal Academy of Arts in association with Merrell Holberton, 1997

Brigid Peppin and Lucy Mickelthwait, *Dictionary of British Book Illustrators: The Twentieth Century*, London: John Murray, 1983

R G G Price, *A History of Punch*, London: Collins, 1957

Gordon N Ray, *The Illustrator and the Book in England from 1790 to 1914*, Oxford University Press, 1975

Jane Turner (editor), *The Dictionary of Art*, London: Macmillan Publishers, 1996 (34 volumes)

Joyce Irene Whalley and Tessa Rose Chester, *A History of Children's Book Illustration*, London: John Murray/ Victoria and Albert Museum, 1988

Gleeson White, *English Illustration. 'The Sixties': 1855-70*, London: Constable & Co, 1897

Andrew Wilton and Robert Upstone, *The Age of Rossetti, Burne-Jones & Watts. Symbolism in Britain 1860-1910*, London: Tate Gallery Publishing, 1997

CUMULATIVE INDEX OF CATALOGUES

(1991-2002)

Dates in bold indicate entire chapters devoted to single illustrators

A

Abbey, Edwin Austin: 1997
Addams, Charles: 1991
Ahlberg, Janet: 1992
Aldin, Cecil: 1991, 1992, 1997, 1999
Allingham, Helen: 1996, 1997
Anderson, Anne: 1991, 1996, 2001
Anton (Beryl Antonia Thompson and Harold Underwood Yeoman Thompson): 1991
Appleton, Honor: **1991**, 1992, 1993, 1997, 1999, 2002
Ardizzone, Edward: 1991, **1992, 1993**, 1997, **1999**, 2001, 2002
Atkinson, Maud Tyndal: 1997
Attwell, Mabel Lucie: 1991, 1992, 1993, 1996, 1997, 1999, **2000**, 2001, 2002
Austen, John: 1991, 1996
Ayrton, Michael: 1993, 1997

B

V A B: 1991
Badmin, Stanley Roy: 1993, 1997
Bailly, Louis: 2000
Bairnsfather, Bruce: 1992, 1999
Ball, Wilfrid: 1997
Banbery, Frederick: 1999, **2000**, 2002
Barker, Cicely Mary: 1991, 1992, 1993, 1999
Barrett, Angela: 1992, 1997, 1999
Bartlett, William: 1997
Barton, Rose: 1997
Bastien, A-T-J: 1992
Batchelor, Roland: 1993
Bateman, Henry Mayo: 1991, 1992, 1993, 1997, 1999, **2000**, 2001
Batt (Oswald Barrett): 1997
Bauerle, Amelia: 1991
Baumer, Lewis: 1991, 1999
Bawden, Edward: 1993, 1997
Baxter, Doreen: 1992, 1997
Baxter, Glen: 1997

Baxter, William Giles: 1993, 1996, 1999
Beadle, James: 1997
Beardsley, Aubrey: 1999, **2000**
Beardsley, Aubrey, Follower of: 1999
Bedford, Francis Donkin: 1997
Beek, Harmsen van der: 1999
Beerbohm, Max: 1992, 1993, 1997, 1999, **2000**, 2002
Begg, Samuel: 1992
Belcher, George: 1991, 1992, 1993, 1996, 1997, 1999, 2002
Bell, Robert Anning: 1993, 1996, 1999
Bentley, Nicholas: 1991
Bernard, C E B: 1999, 2002
Bestall, Alfred: 1993, 1999
Biro, Val: 2002
Blackmore, Katie: 1997
Blair, Preston: 1993, 1999
Blake, Quentin: 1991, 1992, 1997, 1999, 2001
Blampied, Edmund: 1992, 1993
Blathwayt, Ben: 1992, **2000**
Bliss, Douglas Percy: 1993, 1997
Bond, Simon: 1993, 1997, 2001
Bone, Muirhead: 1992
Boswell, James: 1997
Boucher, William Henry: 1993
Bowman, Peter: 1992
Boyd, Tracey: 1992, 1993
Bradshaw, Percy: 1992
Brangwyn, Frank: 1992, **1999**
Brickdale, Eleanor Fortescue: 1991
Brierley, Louise: 1997
Briggs, Raymond: 1993
Brock, Charles Edmund: **1992, 1993**, 1997, 1999
Brock, Henry Matthew: 1991, **1992, 1993**, 1996, 1999
Brockbank, Russell: **2002**
Brookes, Peter: 1993, 1997, 1999
Browne, Tom: 1991, 1992, 1997, 1999
Bryan, Alfred: 1993, 1999
Bull, Rene: 1991, 1992, 1997

Bunbury, Henry William: 1993
Burke, Chris: 1993
Burningham, John: 1993, 2002
Butterworth, Nick: 2002

C

Caldecott, Randolph: 1991, 1992, 1996, 1999
Cameron, John: 1992
Cameron, Katherine: 1993, 1997
Canziani, Estella: 1993, 1996, 1999
Caran d'Ache (Emmanuel Poiré): 1992, 1993, 1999
Carse, A Duncan: 1992, 2001
Casson, Hugh: 1991, 1992, **2002**
Chalon, Alfred Edward: 1993
Cham (Amedée Charles Henri de Noé): 1991
Chapman, Charles Henry: 1999, 2002
Chesterton, Gilbert Keith: 1991, 1993
Churcher, Walter: 1992
Clark, Emma Chichester: 1999
Clarke, Harry: 1991, 1996
Cleaver, Reginald: 1991
Cloke, Rene: 1996, 1999
Cole, Richard: 1992, 1993
Collier, Emily E: 1996
Collins, Clive: 1993
Conder, Charles, Follower of: 1993, 1999
Cowham, Hilda: 1993, 1999
Cox, Paul: 1993, 1997
Crane, Walter: 1996, 1997, 1999, 2002
Cross, Peter: 1991, 1992, 1993, 1996, 1997, 2001, 2002
Crowquill, Alfred: 1993
Cruikshank, George: 1991, 1996, 1999
Cruikshank jnr, George: 1997, 1999
Cruikshank, Isaac: 1991, 1993, 1996, 1999
Cruikshank, Robert: 1993
Cubie, Alex: 1993
Cummings, Michael: 1992, 1997, 1999
Cushing, Howard Gardiner: 1999

D

Dadd, Philip: 1997
Dadd, Richard: 1997
Daley, Mike: 1992
Davis, Jon: 1991, 1992, 1993
Dawson, Eric: 1993
De Grineau, Bryan: 1992
De La Bere, Stephen Baghot: 1991, 1992, 1997, 2001
Dennis, Ada: 1996
Dickens, Frank: 1993, 1997, 1999
Disney, Walt (and the Disney Studio): 1991, 1993, 1999, 2000, 2002
Dixon, Charles: 1992
Doré, Gustave: 1997, 1999
Douglas (Thomas Douglas England): 1992, 1993
Doyle, Charles Altamont: 1991, 1992, 1997, 1999, 2002
Doyle, Richard: 1991, 1993, 1996, 1997, 1999, 2002
Draner, Jules-Renard: 1993
Drew, Simon: 1991, 1992, 1993, 1997, 1999, 2001, 2002
Du Cane, Ella: 1997
Dulac, Edmund: 1991, 1993, 1996, 1997, 2001
Du Maurier, George: 1991, 1992, **1996**, 1997, 1999
Duncan, John: 1991
Duncan, Walter: 1996
Dyson, Will: 1993, 1997, 1999

E

Earnshaw, Harold: 1996
East, Alfred: 1997
Edwards, Lionel: 1992
Egan, Beresford: 1997
Elgood, George Samuel: 1997
Elliott, James: 1997, 1999
Emett, Rowland: 1991, 1992, 1993, 1996, 1997, 1999, 2000, 2001
Emmwood (John Musgrave-Wood): 1991, 1993, 1997, 2002

F

Ferguson, Norman: 1993, 1999
ffolkes, Michael: 1991, 1993, 1997, 1999
Fitzgerald, John Anster: 1991, 1997, 1999
Flanders, Dennis: 1992
Flather, Lisa: 1991
Fletcher, Geoffrey Scowcroft: 1993
Flint, Francis Russell: 1992
Flint, William Russell: 1993
Folkard, Charles: 1991, 1992, 1997
Ford, Henry Justice: 2002
Ford, Noel: 1993
Foreman, Michael: 1991, 1992, 1993, 1997, 1999, **2001**
Foster, Myles Birket: 1991, 1999
Fougasse (Cyril Kenneth Bird): 1991, **1992**, 1993, **1996**, 1999
Fraser, Claude Lovat: 1993
Fraser, Eric: 1991, **1992**, 1993, 1997, 2001, 2002
French, Annie: 1991, 1992, 1997
Frost, William Edward: 1997
Fulleylove, John: 1996, 1997
Fullwood, John: 1997
Furniss, Harry: 1991, 1992, 1996, 1999

G

Gaffney, Michael: 1991
Gardiner, Gerald: 1992, 1997
Gaze, Harold: 1999
Gibson, Charles Dana: 1991, 1999
Gilbert, John: 1993, 1996
Giles, Carl (Ronald): 1991, 1992, 1993, **1996**, 1997, 1999, 2001, 2002
Gilliam, Terry: 1992
Gilroy, John: 1997
Ginger, Phyllis: 1991, 1992, 1993
Glashan, John: 1993
Goble, Warwick: 1997, 2002
Godfrey, Bob: 1993
Goldsmith, Beatrice May: 1996
Goodall, John Strickland: 1991, **1996**, 1997
Goodwin, Harry: 1992
Gould, Francis Carruthers: 1992, 1996, 1999
Gould, Rupert T: 1996

Granville, Walter: 1992
Greeley, Valerie: 1992
Green, Charles: 1991, 1997, 1999
Green, John Kenneth: 1993
Green, Winifred: 1996, 1999
Greenaway, Kate: 1991, 1992, **1996**, 1997, 1999, **2000**, **2001**
Guthrie, Thomas Anstey: 1997

H

I C H: 1997
Haité, George: 1997
Hale, Kathleen: 1991, 1996
Hall, Sidney Prior: 1991
Halswelle, Keeley: 1997
Hampson, Frank: **2002**
Hancock, John: 1999
Hankey, William Lee: 1992, 1999
Hardy, Dorothy: 1991
Hardy, Dudley: 1991, 1992, 1997, 1999
Hardy, Evelyn Stuart: 1993
Haro (Haro Hodson): 1991
Harrold, John: 1993
Hartrick, Archibald Standish: 1999
Hassall, Ian: 1992, 1997
Hassall, Joan: 1992
Hassall, John: 1991, 1992, 1993, 1997, 1999
Hatherell, William: 1991
Hawkins, Colin: 1999
Hay, James Hamilton: 1997
Hayes, Claude: 1997
Haywood, Leslie: 1992
Heath, Michael: 1993
Henderson, Keith: 1992
Hennell, Thomas: 1991
Henry, Thomas: 1999
Herbert, Susan: 1996
Hergé (Georges Remi): 1991
Hickson, Joan: **1993**
Hilder, Rowland: 1997
Hodges, Cyril Walter: 1991, 1993, 1997
Hoffnung, Gerald: 1991, **1992**, 1996, 1997, 1999
Honeysett, Martin: 1999
Hopkins, Arthur: 1996
Hopwood, Henry; 1997
Houghton, Arthur Boyd: 2002

Housman, Laurence: 1991
Howitt, Samuel: 1993
Hughes, Talbot: 1997
Hughes-Stanton, Herbert: 1997
Hunt, William Henry: 1996
Hunt, Follower of William Henry: 1997

I

Illingworth, Leslie: 1992, 1997
Ivory, Leslie Anne: **1993**, 1996

J

Jacobs, Helen: 1992, 1996, 1997, 1999, 2002
Jacques, Robin: 1991, 1992, 1997
Jak (Raymond Allen Jackson): 1991, 1993, 1997, 1999
Jalland, G H: 1997
Janny, Georg: 1992
Jaques, Faith: 1991
Jensen, John: 1991, 1993, 1997
Johnson, Jane: 1991, 1992, 1999
Johnstone, Anne Grahame: 1992, 1997, **1999**
Johnstone, Janet Grahame: 1999
Jon (William John Philpin Jones): 1991

K

Kal (Kevin Kallaugher): 1991, 1992
Kapp, Edmond Xavier: 1999
Keene, Charles: 1991, 1992, 1993, 1997, 1999
Keeping, Charles: 1997
Kimball, Ward: 1993
King, Jessie Marion: 1997, 1999
Knight, Laura: 1993

L

Lamb, Lynton: 1993, 1997
Lancaster, Osbert: 1991, 1993, 1997, 1999
Langdon, David: 1991, 1993, 1997
Langley, Jonathan: 1999, 2000
Langley, Walter: 1997
Lantoine, Fernand: 1992
Larcombe, Ethel: 1999
Larry (Terry Parkes): 1991, 1992, 1993, 1997, 1999
Lear, Edward: 1993, 1996, **2002**
Le Cain, Errol: 1997

Lee, Alan: 1991
Leech, John: 1991, 1992, 1993, 1996
Leman, Martin: 1993
Leonard, Michael: 1991
Leslie, Charles Robert: 1993, 1996
Lewis, John Frederick: 1991
Linton, James Drogmole: 1997
Lodge, G B: 1991
Low, David: 1991, 1993, 1997, 1999, 2001
Lucas, John Seymour: 1997
Lucas, Sydney Seymour: 1993
Lynch, Patrick James: 1992

M

Macbeth-Raeburn, Henry: 1997
Macdonald, Alister K: 1999
Macdonald, R J: 2002
McGill, Donald: 1991, 1992, **1997**, 1999
McLachlan, Edward: 1997, 2002
MacWhirter, John: 1997
Maddocks, Peter: 1993, 1997
Mallet, Dennis: 1991
Mansbridge, Norman: 1991
Marc (Mark Boxer): 1991
Marks, Henry Stacy: 1991, 1997
Marshall, Herbert Menzies: 1997
Marwood, Timothy: 1999
Matania, Fortunio: 1992
Matthews, Rodney: 1991, 1993
Mavrogordato, Alexander: 1997
May, Phil: **1991**, 1992, 1993, **1996**, 1997, 1999
Mays, Douglas Lionel: 1997, 1999
Menpes, Mortimer: 1997, 1999
Meredith, Norman: 1991, 1992, 1993, 1997, 1999
Meugens, Sibyl: 1993
Meyrick, Kathryn: 1991
Midda, Sara: 1991, 1992, 1993
Mill, W: 1999
Millais, John Everett: 2002
Minnitt, Frank J: 2002
Moira, Gerald: 1997
Moore, Frederick: 1993, 1999
Morrow, Edwin: 1993
Morton-Sale, Isobel: 1999, **2002**
Morton-Sale, John: 1997, 1999, **2002**
Munnings, Sir Alfred: 1991

N

Nash, Paul: 1993, 1997
Newman, Henry Roderick: 1996
Nichols, Charles: 1993
Nicholson, William: 1992, 1999
Nielsen, Kay: 1993, 2001
Nixon, John: 1999
Nixon, Kay: 1997

O

Odle, Alan: 1991, 1996
Oppenheimer, Joseph: 1997
Orrock, James: 1997
Ospovat, Henry: 2002
Outhwaite, Ida Rentoul: 1991, 1999

P

Palmer, Harry Sutton: 1991
Parsons, Alfred: 1992, 1997
Partridge, Bernard: 1997, 1999, 2002
Payne, David: 1992
Peake, Mervyn: **1997**, 2002
Pearce, Susan Beatrice: 1996
Pears, Charles: 1991
Pegram, Frederick: 1993
Peploe, William Watson: 1996
Peto, Gladys: 1993
Phiz (Hablot Knight Browne): 1993, 1999
Pickersgill, Frederick Richard: 1997
Pisa, Alberto: 1997
Pogany, Willy: 1992
Pollard, N: 1991, 1996
Pont (Graham Laidler): 1991, 1992, 1993, **1996**, 1999
Potter, Beatrix: 1991, 2002
Poy (Percy Hutton Fearon): 1999
Preston, Chloë: 1999
Protheroe, Thomas: 199
Pullen, Alison: 1993
Pyne, Ken: 1993

Q

Quiz (Powys Evans): 1993

R

Rackham, Arthur: **1991, 1992**, 1993, **1996**, 1997, **1999, 2000**, 2001, **2002**
Raemaekers, Louis: 1992
Ravenhill, Leonard: 1992, 1997, 1999
Reed, Edward Tennyson: 1993, 1996, 1999

Reitherman, Wolfgang: 1993, 1999
Reynolds, Frank: 1991, 1992, 1993, **1996**, 1997, 1999, 2001, 2002
Richards, Frank: 1992
Ricketts, Charles: 1993
Rimington, Alexander: 1997
Ritchie, Alick: 1992
Roberson, Peter: **1992**
Robertson, Henry: 1997
Robinson, Charles: 1992, 1993, 1996, 1997, 1999
Robinson, William Heath: 1991, 1992, 1993, **1996**, 1997, **1999, 2000**, 2001, 2002
Rosoman, Leonard: 1997
Ross, Tony: 1999
Rothenstein, William: 1997
Rountree, Harry: 1991, 1992, 1993, 1997, 1999, 2001
Rowlandson, Thomas: 1991, 1993, 1996, 1999
Rutherston, Albert: 1992

S

Sainton, Charles Prosper: 1997
Salaman, F J B: 1999
Sambourne, Edward Linley: **1996**
Sandy, H C: 1991
Saul, Isabel: 1997
Scarfe, Gerald: 1991, 1992, 1993
Schulz, Charles Monroe: 1991, 1992, 1997
Schwabe, Randolph: 1997
Searle, Ronald: 1991, 1992, **1993**, 1996, **1997, 1999, 2000**, 2001, 2002
Severn, (Joseph) Arthur Palliser: 1996
Shannon, Charles: 1999
Sheldon, Charles Mill: 1999
Shaw, Byam: 1991, 1997
Shepard, Ernest Howard: **1991, 1992, 1993, 1996, 1997, 1999, 2000**, 2001, 2002
Shepherd, William James Affleck: 1993
Shepperson, Claude: 1997
Sheringham, George: 1992, 1997
Sherriffs, Robert Stewart: 1997
Sillince, William: 1991
Sime, Sidney Herbert: 1991, 1996, 1999
Simmons, John: 1997

Simmons, W St Clair: 1999
Simpson, Joseph W: 1993
Slater, Paul: 1999
Slocombe, Edward: 1997
Slocombe, Frederick: 1997
Small, William: 1999
Smythe, Reg: 1993, 1999
Soper, Eileen: 1991, **1997**, 1999
Soper, George: 1991, 1997
Sowerby, Millicent: 1991, 1992
Spare, Austin Osman: 1991, 1996
Sprod, George: 1997, 1999
Spurrier, Steven: 1992, **1999**
Stampa, George Loraine: 1991, 1992, 1993, 1997, 1999
Steadman, Ralph: 1991, 1992, 1996, 1997
Stokes, Adrian: 1997
Stokes, Marianne: 1997
Stothard, Thomas: 1999
Strube, Sidney: 1999
Studdy, George Ernest: 1991, 1992, 1997, 1999
Sullivan, Edmund Joseph: 1991, **1992**, 1997, 1999
Swan, John Macallan: 1997
Swanwick, Betty: **1991**, 1993, 1997

T

Tansend: 1999
Tarrant, Margaret: 1992, 1993, 1996, 1997, 1999, 2002
Tarrant, Percy: 1991
Tenniel, John: 1991, 1992, 1993, 1996, 1997, 1999
Thackeray, Lance: 1992, 1997
Thelwell, Norman: 1991, 1992, 1993, 1997, 1999, 2002
Thomas, Bert: 1991, 1997, 1999
Thomas, Frank: 1993, 1999
Thomas, William Fletcher: 1993, 1996
Thomson, Hugh: 1991, 1997, 1999
Thorpe, James: 1991
Thurber, James: 1991
Tidy, Bill: 1993
Timlin, William Mitcheson: 1996, 1999
Titcombe, Bill: 1999
Topolski, Feliks: 1991
Townsend, Frederick Henry: 1999

Tourtel, Mary: 1993, 1997, **2000**
Tyndale, Walter: 1997
Tyndall, Robert: 1999
Tytla, Bill: 1993, 1999

U

Underhill, Liz: 1992

V

Van Abbé, Salomon: 1997, 1999
Van der Weyden, Harry: 1992
Vaughan, Keith: 1991
Vicky (Victor Weisz): 1991, 1992, 1993, 1997, 1999, 2001, 2002

W

Wain, Louis: 1996
Wainwright, Francis: 1991, 1997
Walker, Frederick: 1991, 1999
Walker, William Henry: 1993, 1996, 1999
Ward, William: 1996
Waterman, Julian: 1993
Wateridge, Jonathan: 2002
Webb, Clifford: **1993**
Webster, Tom: 1992
Weedon, Augustus: 1997
Wehrschmidt, Daniel: 1997
Welch, Patrick: 1991
Wells, Rosemary: 1993
Wheeler, Dorothy: 1991
Whistler, Rex: 1991
Wilkie, David: 1991
Wilkinson, Thomas: 1993
Williams, Mike: 1999, 2002
Wimbush, Henry: 1997
Wood, Lawson: 1991, 1992, 1993, 1997, 1999, 2002
Wood, Starr: 1992, 1997, 1999
Wootton, Reg: 1991
Wright, Alan: 1991, 1996, 1997
Wright, John Massey: 1996
Wright, Patrick: 1993, 1997, 1999
Wyllie, William Lionel: 1997

Y

Yeats, Jack Butler: 1993

Z

Zinkeisen, Anna: 1993

INDEX 2002

	Pages
Appleton, Honor	36-37
Ardizzone, Edward	68-71
Attwell, Mabel Lucie	40-45
Banbery, Fred	92-93
Beerbohm, Max	58-59
Belcher, George	57
Bernard, C E B	31
Biro, Val	74-75
Brockbank, Russell	82-87
Burningham, John	109
Butterworth, Nick	115-116
Casson, Hugh	77-81
Chapman, Charles Henry	62-64
Crane, Walter	13
Cross, Peter	117-119
Disney Studio, Walt	76
Doyle, Charles Altamont	10-11
Doyle, Richard	12
Drew, Simon	114
Emmwood (John Musgrave-Wood)	90-91
Ford, Henry Justice	18-19
Fraser, Eric	72
Giles (Carl Ronald Giles)	89
Goble, Warwick	30
Hampson, Frank	95-101
Houghton, Arthur Boyd	16
Jacobs, Helen	38
Lear, Edward	7-9
Macdonald, R J	67
McLachlan, Edward	110-111
Millais, John Everett	14-15
Minnitt, Frank J	65-66
Morton-Sale, Isobel	46-49
Morton-Sale, John	46-49
Ospovat, Henry	20-21
Partridge, Bernard	58
Peake, Mervyn	73
Potter, Beatrix	34-35
Rackham, Arthur	22-29
Reynolds, Frank	60
Robinson, William Heath	32-33
Searle, Ronald	102-108
Shepard, Ernest Howard	50-56
Tarrant, Margaret	38-39
Thelwell, Norman	94
Vicky (Victor Weisz)	88
Wateridge, Jonathan	112-113
Williams, Mike	114
Wood, Lawson	61

258 (see page 117)